P9-EDD-756

Eleonore & Maurice

CUTE AMIGURUMI ANIMALS

16 adorable creatures to crochet

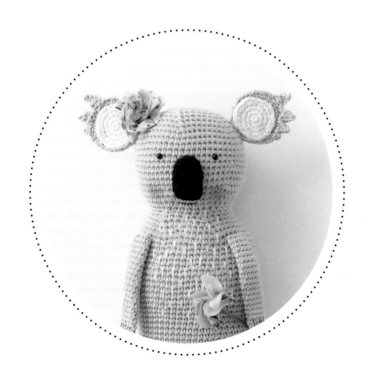

SEARCH PRESS

First published in Great Britain in 2020 by
Search Press Limited
Wellwood, North Farm Road,
Tunbridge Wells, Kent TN2 3DR

© 2018, Libella, Paris

This translation of 'DOUDOUS DOUX AU CROCHET & EN LIBERTY'
first published in France by LIBELLA under the imprint LTA in
2018 is published by arrangement with Silke Bruenink Agency,
Munich, Germany.

English translation by Burravoe Translation Services

Photographs: Fabrice Besse
Styling: Sonia Roy
Photogravure: Nord Compo

ISBN 978-1-78221-740-4

All rights reserved. No part of this book, text, photographs or
illustrations may be reproduced or transmitted in any form or by
any means by print, photoprint, microfilm, microfiche, photocopier,
internet or in any way known or as yet unknown, or stored in a
retrieval system, without written permission obtained beforehand
from Search Press. Printed in China.

The Publishers and author can accept no responsibility for any
consequences arising from the information, advice or instructions
given in this publication.

Readers are permitted to reproduce any of the items in this book for
their personal use, or for the purposes of selling for charity, free of
charge and without the prior permission of the Publishers. Any use
of the items for commercial purposes is not permitted without the
prior permission of the Publishers.

If you have difficulty in obtaining any of the materials and equipment
mentioned in this book, then please visit the Search Press website
for details of suppliers:
www.searchpress.com

Acknowledgements
Warm thanks to:
my readers: the idea that you will crochet one of these little soft toys
fills me with delight!
Charlotte of etpuislaneigeelleesttropmolle.blogspot.com:
it is thanks to her that you have this book in your hands;
the Instagram community for its generosity and all my
creative friends;
Le Temps Apprivoisé and in particular Anne-Sophie and Isabelle for
their trust and professionalism;
Fabrice Besse and Sonia Roy for having put so much effort into
immersing themselves in the Eleonore & Maurice world;
Stragier, who provided the Liberty print, and in particular Nicolas
and Cédric for their enthusiasm and advice;
DMC France, who provided the yarn, and especially Charline;
my mother for having passed on her love of yarn craft.

CONTENTS

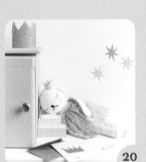

Princess Fleur

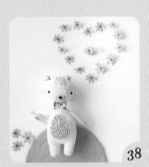

Jacques, a most unusual goat

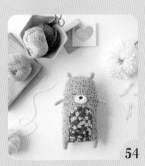

Bertie the furry bear

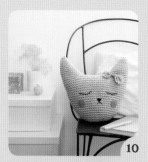
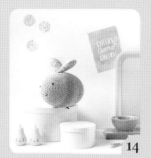
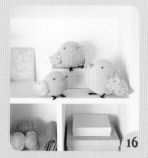
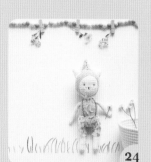
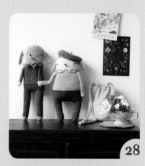
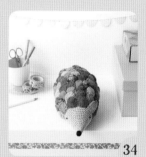
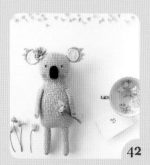
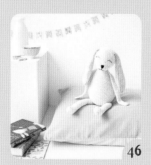
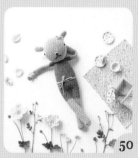
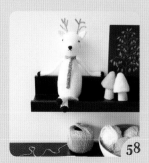
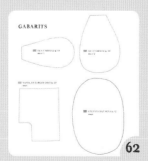

MATERIALS & TOOLS

I love the stage of choosing my materials… It is something I like to take my time over! I start with the fabric: do I want a small or large pattern? Bright or muted colours? Then I match the yarn as closely as possible to the fabric, adding a small contrast touch where I can. Then do as I do, enjoy yourself!

THE YARN

Crochet can be very time-consuming, so I prefer to work with **high-quality yarns** that do justice to the amount of time you invest in your projects. For soft toys, I prefer **natural, cotton yarns**, with no acrylic content. I find they are softer to the touch. Personally I prefer matt yarns – this is why I use DMC Natura cotton – but you can choose whichever yarn you like. Just make sure you adapt the size of the crochet hook accordingly and check the yardage to ensure that you have enough yarn to finish the project.

For the reindeer on page 58, I crocheted using gold **metallic yarn** to give him an elegant, festive touch. For the embroidery, or when I am doubling the thread to create a speckled effect, I use the **fine yarn** in DMC's Special Dentelles range. Experiment, play around, just have fun!

Sewing thread colour-matched to the fabric should be used for sewing the animals' clothes.

THE HOOKS

I started out using **basic** hooks, but then I invested in more comfortable **ergonomic** hooks. However, you will get the same result whichever you use.

For the projects in this book, I used **three sizes of hook**: 2.5mm (UK 12, US C/2), 2mm (UK 14, US B/1) and 5.5mm (US I/9, UK 5). I always prefer to use a hook size half a size smaller than the one recommended by the yarn manufacturer. This reduces the holes between the stitches so the stuffing cannot escape.

THE FABRICS

I have opted for Liberty Tana Lawn: it is a beautiful fabric in fine, soft, silky cotton available in multiple colours and patterns. For most of the projects, offcuts will be absolutely fine.

If you do not have any Liberty fabric, you can replace it with any other fine, soft fabric. You can also buy little offcuts of Liberty on the internet or in fabric shops. That is how my Liberty collection began!

ACCESSORIES

For some of the animals, you will need two snap-on **safety eyes**, available in different sizes and colours. Sew-on glass eyes are another option.

You will also need **stuffing**. I prefer to use synthetic, anti-dust-mite stuffing, but there are more natural alternatives made of linen, kapok or cotton.

You will need various different types of needles: **a large, round-tipped needle** for weaving in loose ends and sewing the different pieces of crochet together, **a sharp-ended embroidery needle** and **a sewing needle** for sewing fabric. **Pins** come in handy for the sewing or to hold the ears or arms of the animals in place before you sew them on.

Use a **stitch marker** to mark the start of a round, or like me, use a piece of yarn knotted into a loop.

A **tape measure** and a **pair of scissors** are also essentials.

Stitching can be done **by hand** or on a **sewing machine**.

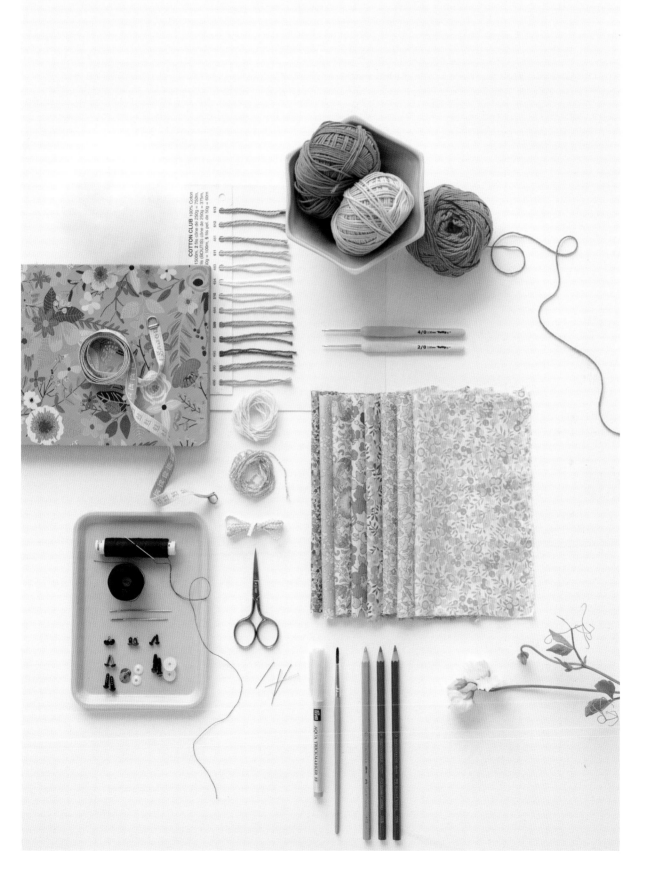

HOW TO CROCHET

HOLDING THE HOOK

People generally hold a crochet hook like a pen, with the other hand controlling yarn tension. Personally, I prefer to hold it like a knife or fork.

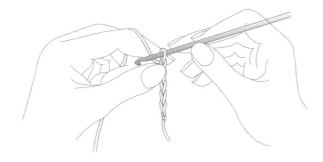

ADJUSTABLE RING

Make a loop with the end of the yarn, then hold it between your fingers. Pass the hook through this loop and then wrap the yarn over the hook: catch the yarn by rolling it round the end of the hook (1). Draw the yarn back through the loop (2). Continue in the same way (3).

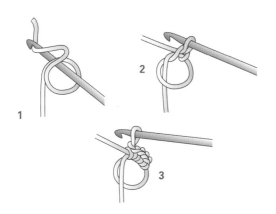

CHAIN STITCH (CH)

Make a loop and insert your hook (1). Yarn over the hook and draw through the loop (1). This is a slip knot. Yarn over the hook and draw through the loop to create your first chain stitch (2). Repeat as many times as your pattern requires.

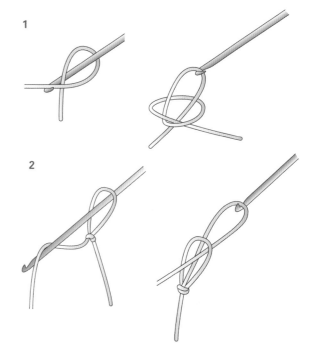

COUNTING STITCHES

Stitches are counted as shown in the diagram below. The adjustable ring and the loop that is on the hook do not count.

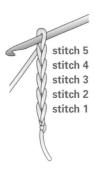

stitch 5
stitch 4
stitch 3
stitch 2
stitch 1

SLIP STITCH (SL ST)

This stitch is used to tie off your work before cutting the yarn and also for joining two pieces of crochet together. For example, in this book, use slip stitches to join the points of a crown to its base. Insert the hook into the stitch where you want to form the slip stitch, yarn over, then pull the loop back through the stitch and the loop that is on your hook.

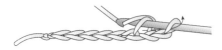

DOUBLE CROCHET (DC)

In the US, this is known as single crochet (sc)
Insert the hook into the stitch, yarn over, then pull the yarn back through the stitch (1). You now have two loops on the hook (2). Yarn over again and pull the yarn through both loops (3). Repeat to make more stitches (4).

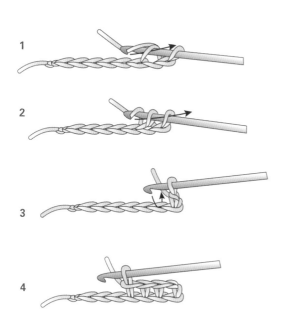

HALF TREBLE CROCHET (HTR)

In the US, this is known as half double crochet (hdc)
Yarn over, insert the hook through the next stitch (1). Yarn over again and draw the yarn back through the stitch. You now have three loops on the hook (2). Yarn over again and draw the yarn through all three loops (2 and 3).

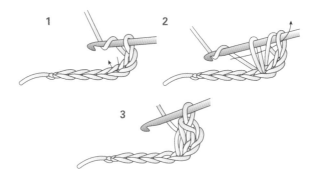

TREBLE CROCHET (TR)

In the US, this is known as double crochet (dc)
Yarn over, insert the hook through the next stitch (1). Yarn over again and draw the yarn back through the stitch. You now have three loops on the hook (2). Yarn over again and pull the yarn through the first two loops on the hook (2). There are now two loops on the hook. Yarn over for the last time and pull the yarn through the two remaining loops (3 and 4).

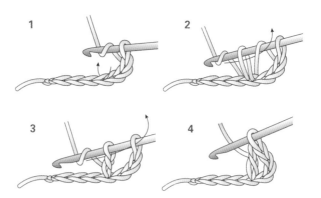

DOUBLE TREBLE (DTR)

In the US, this is known as treble crochet (tr)

Yarn over twice, then insert the hook through the next stitch (1). Yarn over again and draw the yarn back through the stitch. You have four loops on the hook (2). Yarn over again and draw the yarn through the first two loops (2). There are now three loops on the hook. Yarn over again and draw the yarn through the first two loops (3). There are now two loops on the hook (4). Yarn over for the last time and pull the yarn through the two remaining loops (4 and 5).

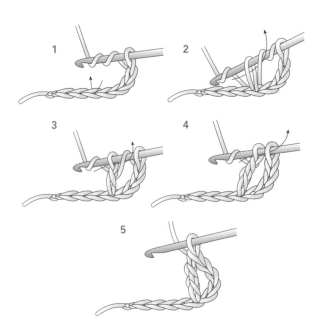

WORKING IN ROWS (BACK AND FORTH)

Crochet a foundation chain to the required length and work the first row in the chosen stitch.

Turn the work over. Crochet the given number of chain stitches to start the second row and continue in the required stitch.

At the end of this row, turn the work again and continue as instructed.

WORKING IN ROUNDS

All the animals in this book are crocheted using this technique. A spiral is created as each row is worked into the one before. Place a stitch marker at the beginning of the round so you know where the start is.

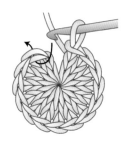

DECREASES IN DOUBLE CROCHET: DC2TOG

In the US, this is known as decreases in single crochet: sc2tog

Insert the hook into the next stitch, yarn over, then draw the yarn back through the stitch (1). You now have two loops on the hook. Insert the hook into the next stitch, yarn over, then draw the yarn back through the stitch (2). You now have three loops on the hook. Yarn over again, then draw the yarn through all three loops (3).

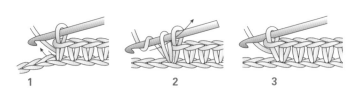

INCREASES

Work the same stitch (double crochet, single crochet etc.) twice in the same stitch.

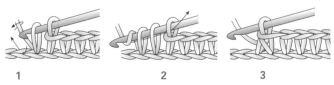

SPECIAL WORDS
AND INSTRUCTIONS

ASTERISKS

Asterisks indicate a part of the instructions that is to
be repeated.
For example: *2 dc in 1 st, 3 dc*until end means that you must
alternate two double crochets in one stitch with three double
crochets until the end of the round.

ABBREVIATIONS

The following abbreviations are used in this book to make
instructions quicker and easier to read.
Please note: all of the patterns in this book have been written
using UK terminology. For readers in the US, the equivalent US
terms are provided below.

chain stitch	ch
decrease	dec
treble crochet	tr (US dc)
half treble crochet	htr (US hdc)
increase	inc
double crochet	dc (US sc)
double treble crochet	dtr (US tr)
slip stitch	sl st
stitch	st
together	tog

PROJECT DIFFICULTY LEVELS

The difficulty levels can be found at the top of the first page of
each project.

 Very easy

 Easy

 More difficult

SEWING

Use straight stitch and running stitch to assemble the pieces
of fabric.
If you are sewing by hand, you will use straight stitch and slip
stitch to sew up some of the pieces.
Some of the animals' clothes require hems. For this, turn
under 1cm (½in) at the bottom of the item of clothing (skirt or
trousers), wrong sides together, and sew on a sewing machine,
or sew by hand using slip stitch.
Use a water-soluble pen, chalk or even a pencil to copy
the templates.
Press the seams with an iron to ensure a perfect finish.

EMBROIDERY

Use satin stitch to embroider the creatures' muzzles. Embroider
the outline then fill in with satin stitch.

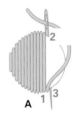

TO FINISH

The creatures' cheeks are coloured using a soft paintbrush and
watercolour pencils diluted with a little water in a saucer.
On the edge of the saucer, draw some lines with the
watercolour pencil, pressing quite hard so the colour transfers
well to the plate. Put a little water in the centre and mix the
colour and the water with the paintbrush. Test the colour on a
white handkerchief: if it is too dark, add slightly more water.
I always use very diluted colours (except for the koala on
page 42, where I have made it more intense so it is clearly
visible against the darker yarn). It is up to you to find the
perfect shade!

MINA THE CAT CUSHION

Soft toy, cushion, or both... just like a real cat, Mina curls up in the most comfortable corners of the house.

MATERIALS

* Du fil DMC Natura Just Cotton XL:
 – Guimauve: 250g
* Du fil DMC Natura Just Cotton:
 – Geranium: a few strands
 – Noir: a few strands
* 5.5mm (UK 5, US I/9) and 2.5mm (UK 12, US C/2) crochet hooks
* Tapestry needle
* Toy stuffing
* Liberty Wiltshire fabric, Sweet Pea: 18 x 12cm (7 x 4¾in)
* Erasable pen
* Embroidery needle
* Thick needle
* Stitch marker
* Sewing equipment

FINISHED SIZE: 28 x 28cm (11 x 11in)

HEAD

Start the head by crocheting the ears. This piece is worked in the round, using a 5.5mm (UK 5, US I/9) hook.

FIRST EAR

Using Guimauve yarn, make an adjustable ring (see page 6).
Round 1: 5 dc in the loop, join with a sl st in first dc, then draw tight using the tail of yarn (5 sts).
Round 2: *2 dc in 1 st* three times, 2 dc (8 sts).
Round 3: 1 dc, *2 dc in 1 st* three times, 4 dc (11 sts).
Round 4: 3 dc, *2 dc in 1 st* three times, 5 dc (14 sts).
Round 5: 6 dc, *2 dc in 1 st* twice, 6 dc (16 sts).
Round 6: 7 dc, *2 dc in 1 st* twice, 7 dc (18 sts).
Round 7: 8 dc, *2 dc in 1 st* twice, 8 dc (20 sts).
Round 8: 9 dc, *2 dc in 1 st* twice, 9 dc (22 sts).
Round 9: 10 dc, *2 dc in 1 st* twice, 10 dc (24 sts).
Round 10: 12 dc, 2 dc in 1 st, 11 dc (25 sts).
Fasten off with a sl st and cut yarn leaving a 20cm (7¾in) tail.

SECOND EAR

Make a second identical ear, but after round 10, continue as follows to join the two ears using a chain:
Note: at the end you will have 78 dc, but it is a slightly tricky stage as you can easily get lost between the stitches. Your final number may be anywhere between 74 and 82 dc! If this is the case, rather than redoing, adapt the number of dc in the next round by working the necessary number of inc (2 dc in 1 st) or dec (dc2tog) required to obtain 78 dc. Make these adjustments around the ears, preferably where they meet the head.
Round 11: work 12 dc around the ear. Work 14 ch.
Take the first ear: flatten it, with the pointed end down and the more slanted edge towards the chain. Join the ear to the chain using 1 dc in the 12th st of the ear (i.e. the middle of the slanted side of the ear). Continue with 1 dc in each st until you are back at the chain.

Remember: dc = sc in the US

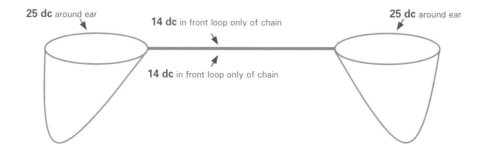

25 **dc** around ear 14 **dc** in front loop only of chain 25 **dc** around ear

14 **dc** in front loop only of chain

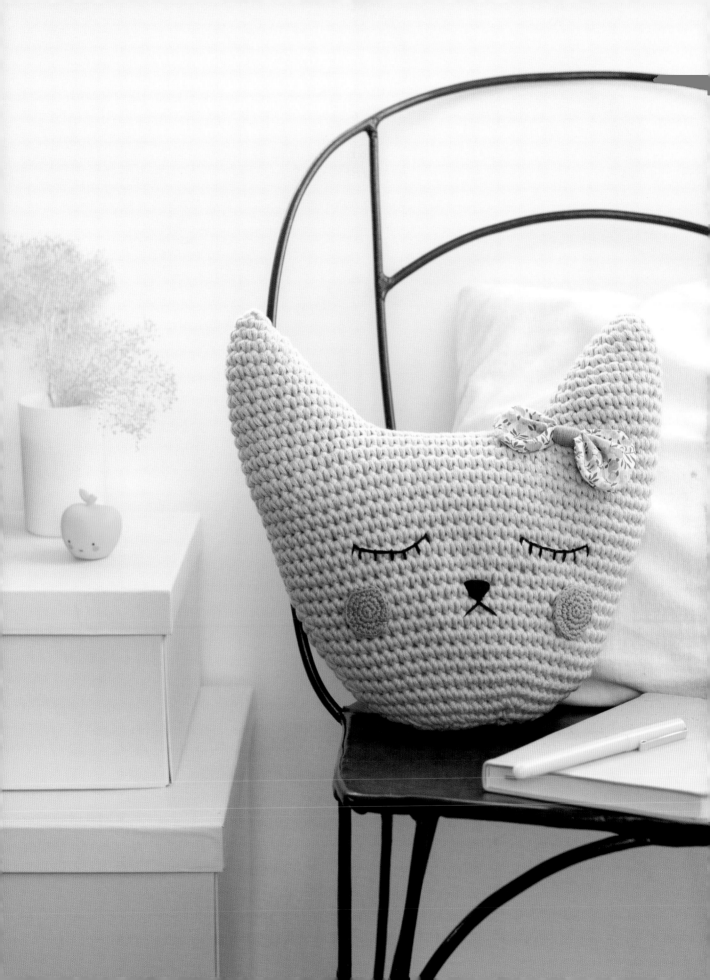

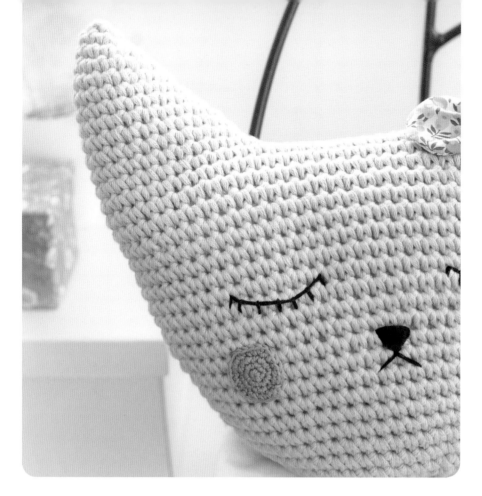

Work 14 dc in front loop only of chain until you have reached the second ear.

Work 25 dc round this ear. You have arrived at the chain again. Continue with 14 dc in front loop only of chain.

You should have 25 dc for the first ear + 14 dc along chain + 25 dc for the second ear + 14 dc back along chain (78 sts). Mark the start of the new round so you do not lose track of where you are.

Round 12: 1 dc in each st (78 sts).
Round 13: 12 dc, dc2tog, 37 dc, dc2tog, 25 dc (76 sts).
Round 14: 1 dc in each st (76 sts).
Round 15: 12 dc, dc2tog, 36 dc, dc2tog, 24 dc (74 sts).
Round 16: 1 dc in each st (74 sts).
Round 17: 12 dc, dc2tog, 35 dc, dc2tog, 23 dc (72 sts).
Round 18: 1 dc in each st (72 sts).
Round 19: 12 dc, dc2tog, 34 dc, dc2tog, 22 dc (70 sts).
Round 20: 12 dc, dc2tog, 33 dc, dc2tog, 21 dc (68 sts).
Round 21: 12 dc, dc2tog, 32 dc, dc2tog, 20 dc (66 sts).
Round 22: 12 dc, dc2tog, 31 dc, dc2tog, 19 dc (64 sts).
Round 23: 12 dc, dc2tog, 30 dc, dc2tog, 18 dc (62 sts).
Round 24: 12 dc, dc2tog, 29 dc, dc2tog, 17 dc (60 sts).
Round 25: 12 dc, dc2tog, 28 dc, dc2tog, 16 dc (58 sts).
Round 26: 12 dc, dc2tog, 27 dc, dc2tog, 15 dc (56 sts).
Round 27: 12 dc, dc2tog, 26 dc, dc2tog, 14 dc (54 sts).

Round 28: 8 dc, *dc2tog* twice, 24 dc, *dc2tog* twice, 14 dc (50 sts).
Round 29: 7 dc, *dc2tog* twice, 22 dc, *dc2tog* twice, 13 dc (46 sts).
Stuff the ears.
Round 30: dc2tog, 4 dc, *dc2tog, 3 dc* to end (37 sts).
Round 31: dc2tog, 3 dc, *dc2tog, 2 dc* to end (28 sts).
Stuff the head.
Round 32: *dc2tog* to end (14 sts).
Round 33: *dc2tog* to end (7 sts).
Fasten off with a sl st and cut yarn leaving a 20cm (7¾in) tail. Close up the small hole with a stitch.

CHEEKS (MAKE TWO)

Using Geranium yarn and a 2.5mm (UK 12, US C/2) hook, make an adjustable ring. This piece is worked in a spiral.
Round 1: 6 dc in the loop, join with a sl st in first dc, then draw tight using the initial yarn tail (6 sts).
Round 2: 2 dc in each st (12 sts).
Round 3: *2 dc in 1 st, 1 dc* to end (18 sts).
Round 4: *2 dc, 2 dc in 1 st* to end (24 sts).
Fasten off with a sl st, and cut yarn leaving a 30cm (11¾in) tail.

LIBERTY FABRIC BOW

1. Fold the fabric right sides together to form a 9 x 12cm (3½ x 4¾in) rectangle. Trace the bow template (see page 62), adding a 0.5cm (¼in) seam allowance, and cut out.
2. Sew using a sewing machine or by hand, leaving a 2cm (¾in) opening. Turn the resulting oval right side out. Do not stuff. Sew up the opening by hand.
3. Pinch the middle of the oval to form a bow. Use a few stitches to hold the shape in place. Secure the ends of the threads before cutting.
4. Take the Geranium yarn and wind it round the middle of the bow a few times, then tie off with a knot at the back, leaving a 20cm (7¾in) tail.

FACE

Using Noir yarn, embroider the face:
- the eyes between rounds 20 and 21 (the eyes are around 7 dc wide).
- the nose between rounds 23 and 25.
- the mouth just below the nose.

MAKING UP

1. Sew on the bow at the base of the ear, at a slight angle.
2. Sew on the cheeks beneath the eyes, approximately two rounds below the eyelashes.

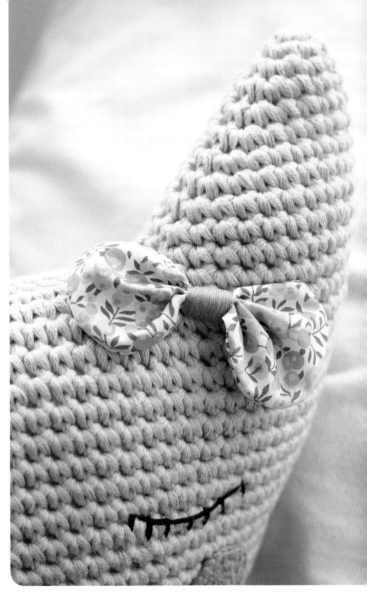

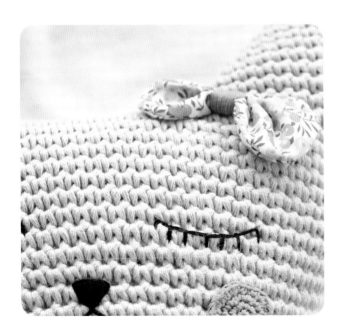

Tip

You can replace the Liberty bow with a crown, following the instructions for the princess crown on page 22. Use DMC Natura Just Cotton Golden Lemon doubled and a 3mm (UK 11, US D/3) crochet hook.

OLA THE BEE

A super-simple bee, perfect for beginners or crochet enthusiasts who are short of time.

···· MATERIALS ··
* DMC Natura Just Cotton:
 – Agatha: 25g
 – Azur: 25g
 – Noir: a few strands
* 2.5mm (UK 12, US C/2) crochet hook
* Stitch marker
* Liberty Margaret Annie fabric, colour E: 20 x 15cm (7¾ x 6in)
* Two black safety eyes, 4mm in diameter
* Black embroidery thread: a few strands
* Embroidery needle
* Sewing equipment
* Toy stuffing
* Erasable pen

FINISHED SIZE: 13 x 17cm (5 x 6¾in)

BODY

Using Agatha yarn, make an adjustable ring (see page 6). This piece is worked in the round.

Round 1: 6 dc in the loop, join with a sl st in first dc, then draw tight using the yarn tail (6 sts).

Round 2: 2 dc in each st (12 sts).

Round 3: *2 dc in 1 st, 1 dc* to end (18 sts).

Round 4: *2 dc in 1 st, 2 dc* to end (24 sts).

Round 5: *2 dc in 1 st, 3 dc* to end (30 sts).

Round 6: *2 dc in 1 st, 4 dc* to end (36 sts).

Round 7: *2 dc in 1 st, 5 dc* to end (42 sts).

Round 8: 1 dc in each st (42 sts).

Round 9: *2 dc in 1 st, 6 dc* to end (48 sts).

Round 10: 1 dc in each st (48 sts).

Round 11: *2 dc in 1 st, 7 dc* to end (54 sts).

Round 12: 1 dc in each st (54 sts).

Round 13: *2 dc in 1 st, 8 dc* to end (60 sts).

Rounds 14–15: 1 dc in each st (60 sts).

Round 16: *2 dc in 1 st, 9 dc* to end (66 sts).

Round 17: 1 dc in each st (66 sts).
Continue with Azur yarn.

Rounds 18 and 19: 1 dc in each st (66 sts).

Round 20: *2 dc in 1 st, 10 dc* to end (72 sts).

Rounds 21–23: 1 dc in each st (72 sts).Continue with Agatha yarn.

Rounds 24–28: 1 dc in each st (72 sts).

Round 29: *dc2tog, 10 dc* to end (66 sts). Continue with Azur yarn.

Rounds 30 and 31: 1 dc in each st (66 sts).

Round 32: *dc2tog, 9 dc* to end (60 sts).

Rounds 33 and 34: 1 dc in each st (60 sts).

Round 35: *dc2tog, 8 dc* to end (54 sts). Continue with Agatha yarn.

Round 36: 1 dc in each st (54 sts).

Round 37: *dc2tog, 7 dc* to end (48 sts).

Round 38: 1 dc in each st (48 sts).

Round 39: *dc2tog, 6 dc* to end (42 sts).

Round 40: 1 dc in each st (42 sts).

Round 41: *dc2tog, 5 dc* to end (36 sts).Continue with Azur yarn.

Round 42: 1 dc in each st (36 sts).

Round 43: *dc2tog, 4 dc* to end (30 sts).

Round 44: *dc2tog, 3 dc* to end (24 sts). Attach eyes between rounds 8 and 9, spaced 16 sts apart. Stuff the body.

Round 45: *dc2tog, 2 dc* to end (18 sts).

Round 46: *dc2tog, 1 dc* to end (12 sts).

Round 47: *dc2tog* to end (6 sts).
Fasten off with a sl st and cut yarn leaving a 20cm (7¾in) tail. Close up the hole with a stitch.

LEGS (MAKE TWO)

Using Noir yarn, and leaving a 25cm (9¾in) tail, work 4 ch. Leave 25cm (9¾in) of yarn before cutting. Fasten off the chain. Weave in yarn end.

FABRIC WINGS

1. Fold the fabric right sides together to form a 10 x 15cm (4 x 6in) rectangle. Trace wing template (see page 62), adding a 0.5cm (¼in) seam allowance, and cut out. Sew together, leaving a 2cm (¾in) opening.

2. Turn the wings the right side out and stuff until firm. The wings should point upwards once attached to the body. Sew up the opening.

MAKING UP

1. Sew the legs onto the body.

2. Sew the wings onto the body, placing them one behind the other rather than next to each other.

3. Using the embroidery thread, embroider a smiling mouth.

Remember: dc = sc in the US

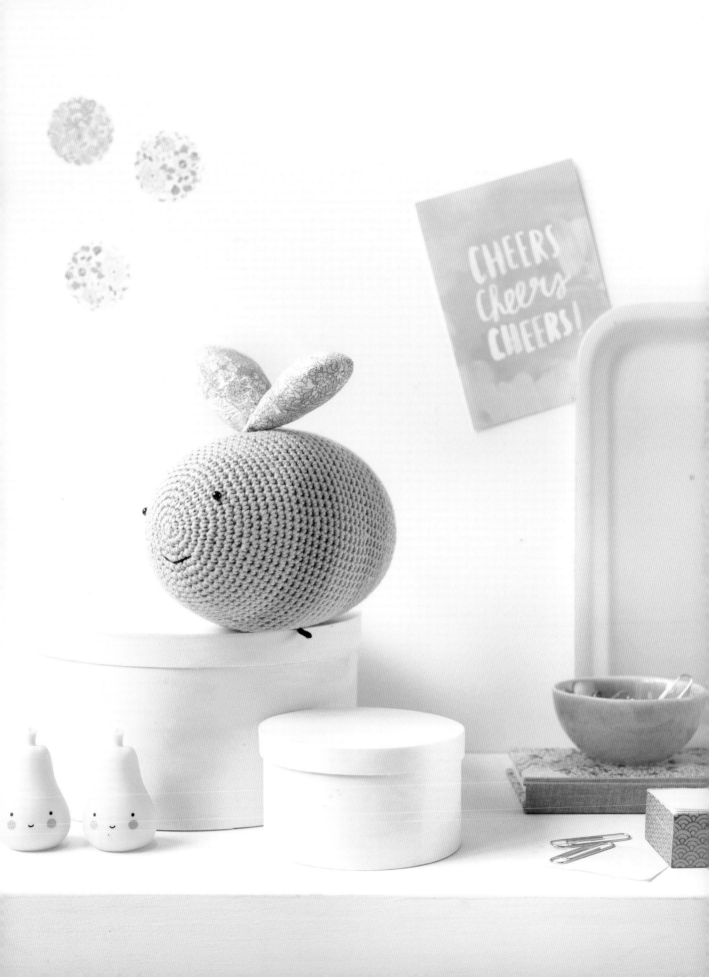

BIRD FAMILY

Pastel colours and floral patterns for these birds.
Listen... can you hear them chirping?

··· **MATERIALS** ···

* DMC Natura Just Cotton:
 – Noir: 15g
 – Safran: 10g
* 2.5mm (UK 12, US C/2) crochet hook
* Stitch marker
* Liberty Betsy fabric, yellow: 60 x 15cm (23½ x 6in)
* Erasable pen
* Sewing equipment
* Toy stuffing

DADDY BIRD (FINISHED SIZE: 14 x 13CM (5½ x 5IN))
* DMC Natura Just Cotton, Acanthe: 40g
* Two pale green 6mm safety eyes

MUMMY BIRD (FINISHED SIZE: 12 x 11CM (4¾ x 4¼IN))
* DMC Natura Just Cotton, Golden Lemon: 35g
* Two pale pink 6mm safety eyes

BABY BIRD (FINISHED SIZE: 9 x 8CM (3½ x 3¼IN))
* DMC Natura Just Cotton, Rose Soraya: 25g
* Two orange 6mm safety eyes

DADDY BIRD'S BODY

Using Acanthe yarn, make an adjustable ring (see page 6). This piece is worked in the round.

Round 1: work 6 dc into the loop, join with a sl st in first dc, then draw tight using the initial yarn tail (6 sts).
Round 2: 2 dc in each st (12 sts).
Round 3: *2 dc in 1 st, 1 dc* to end (18 sts).
Round 4: *2 dc in 1 st, 2 dc* to end (24 sts).
Round 5: *2 dc in 1 st, 3 dc* to end (30 sts).
Round 6: *2 dc in 1 st, 4 dc* to end (36 sts).
Round 7: *2 dc in 1 st, 5 dc* to end (42 sts).
Round 8: *2 dc in 1 st, 6 dc* to end (48 sts).
Round 9: *2 dc in 1 st, 7 dc* to end (54 sts).
Round 10: *2 dc in 1 st, 8 dc* to end (60 sts).
Round 11: *2 dc in 1 st, 9 dc* to end (66 sts).
Round 12: *2 dc in 1 st, 10 dc* to end (72 sts).
Round 13: *2 dc in 1 st, 11 dc* to end (78 sts).
Round 14: *2 dc in 1 st, 12 dc* to end (84 sts).
Round 15: *2 dc in 1 st, 13 dc* to end (90 sts).
Rounds 16–31: 1 dc in each st (90 sts).
Start decreasing:
Round 32: *dc2tog, 13 dc* to end (84 sts).
Round 33: *dc2tog, 12 dc* to end (78 sts).
Round 34: *dc2tog, 11 dc* to end (72 sts).
Round 35: *dc2tog, 10 dc* to end (66 sts).
Round 36: *dc2tog, 9 dc* to end (60 sts).
Round 37: *dc2tog, 8 dc* to end (54 sts).
Round 38: *dc2tog, 7 dc* to end (48 sts).
Round 39: *dc2tog, 6 dc* to end (42 sts).

Round 40: *dc2tog, 5 dc* to end (36 sts).
Round 41: *dc2tog, 4 dc* to end (30 sts).
Round 42: *dc2tog, 3 dc* to end (24 sts).
Attach safety eyes between rounds 11 and 12. Stuff the body.
Round 43: *dc2tog, 2 dc* to end (18 sts).
Round 44: *dc2tog, 1 dc* to end (12 sts).
Round 45: *dc2tog* to end (6 sts).
Fasten off with a sl st and cut yarn leaving a 20cm (7¾in) tail. Close up the small hole with a stitch.

MUMMY BIRD'S BODY

Follow the instructions for Daddy Bird's body up to round 13 (78 sts), using Golden Lemon yarn.
Rounds 14–26: 1 dc in each st (78 sts).
Rounds 27–38: follow the instructions for the Daddy Bird's body from round 34.

BABY BIRD'S BODY

Follow the instructions for Daddy Bird's body up until round 10 (60 sts), using Rose Soraya yarn.
Rounds 11–20: 1 dc in each st (60 sts).
Rounds 21–29: follow the instructions for Daddy Bird's body from round 37, but attach the eyes between rounds 7 and 8.

Remember: dc = sc in the US

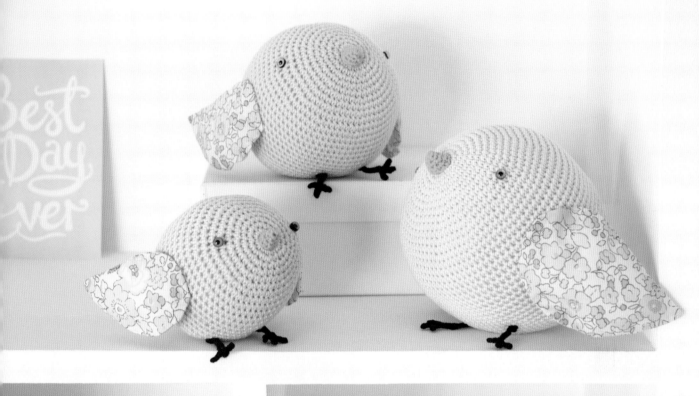

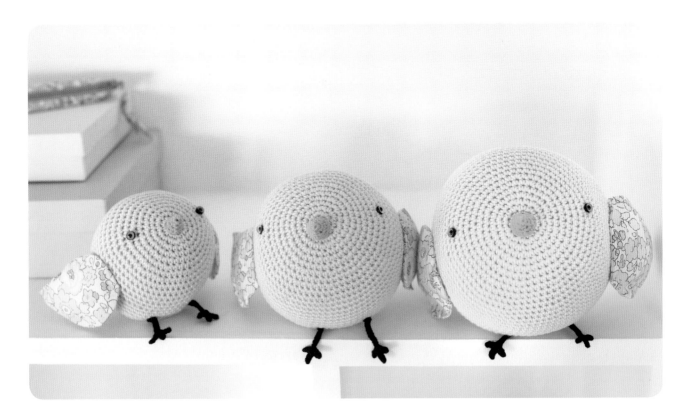

BEAK (MAKE THREE)

Using Safran yarn, make an adjustable ring. This piece is worked in the round.

Round 1: 4 dc in the loop, join with a sl st in first dc, then close the hole by pulling the yarn tail tight (4 sts).

Round 2: *2 dc in 1 st, 1 dc* to end (6 sts).

Round 3: *2 dc in 1 st, 1 dc* to end (9 sts).

Round 4: *2 dc in 1 st, 2 dc* to end (12 sts). Fasten off with a sl st and cut yarn leaving a 35cm (13¾in) tail.

LEGS (MAKE SIX)

Using Noir yarn, work 10 ch. You will work the length of this chain from end to beginning to create the leg.

Work 1 picot stitch as follows: 3 ch, 1 dc in the third ch from the hook. This picot stitch will be the sole of the foot.

First claw: 3 ch, turn the work and work 1 sl st in the second ch and 1 sl st in the third ch, then 1 sl st in the centre of the picot stitch.

Second claw: 3 ch, 1 sl st in the second ch, 1 sl st in the third ch, then 1 sl st in the centre of the picot stitch.

Third claw: 3 ch, 1 sl st in the second ch, 1 sl st in the third ch, then 1 sl st in the centre of the picot stitch.

Turn the work.

Work back up the chain with 1 dc in each ch.

Fasten off with a sl st and cut yarn leaving a 20cm (7¾in) tail.

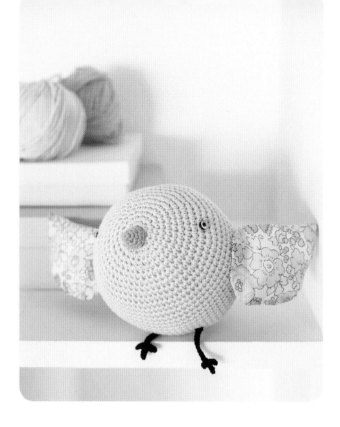

WINGS

1. Fold the fabric right sides together to form a 30 x 15cm (11¾ x 6in) rectangle.

2. Trace the templates for the Daddy, Mummy and Baby Bird's wings twice each (see page 64), adding a 0.5cm (¼in) seam allowance, and cut out. This will give you four wing pieces per bird which, once sewn together, will make two complete wings.

3. Sew up on a sewing machine or by hand, leaving a 2cm (¾in) opening. Turn the wing the right side out and stuff very lightly. Sew up the opening by hand.

MAKING UP

1. Sew on the beak over the adjustable ring.

2. Sew on the legs, positioning them so that they are not perpendicular, but angled forward slightly (the claws should be oriented towards the beak).

3. Only attach the front edge of the wings so they can move easily.

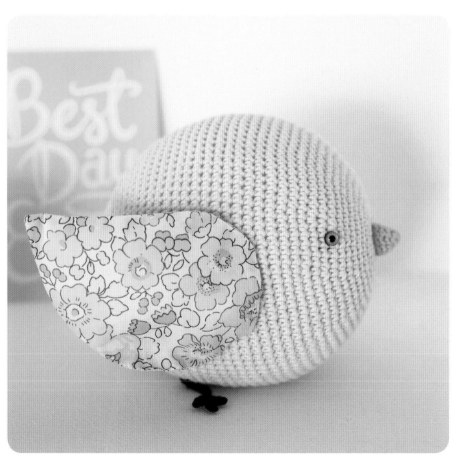

PRINCESS FLEUR

**Fleur is a very delicate princess, with her pretty Liberty print skirt:
a real Princess and the Pea!**

MATERIALS

- ❋ DMC Natura Just Cotton yarn:
 - Ivory: 45g
 - Lobelia: 15g
 - Golden Lemon: a few strands
 - Noir: a few strands
- ❋ 2.5mm (UK 12, US C/2) and 2mm (UK 14, US B/1) crochet hooks
- ❋ Stitch marker
- ❋ Liberty Poppy and Daisy fabric , colour B: 60 x 14cm (23½ x 5½in)
- ❋ Erasable pen
- ❋ A piece of very narrow elastic 10cm (4in)
- ❋ Black embroidery thread: a few strands
- ❋ Pink watercolour pencil
- ❋ Sewing equipment
- ❋ Toy suffing

FINISHED SIZE: 11 x 32cm (4¼ x 12½in)

HEAD

Using Ivory yarn and a 2.5mm (UK 12, US C/2) crochet hook, make an adjustable ring (see page 6). This piece is worked in the round.

Round 1: 6 dc in the loop, join with a sl st in first dc, then draw tight using the initial yarn tail (6 sts).
Round 2: 1 dc in each st (6 sts).
Round 3: *2 dc in 1 st, 1 dc* to end (9 sts).
Round 4: *2 dc in 1 st, 2 dc* to end (12 sts).
Round 5: *2 dc in 1 st, 1 dc* to end (18 sts).
Round 6: *2 dc in 1 st, 2 dc* to end (24 sts).
Round 7: *2 dc in 1 st, 3 dc* to end (30 sts).
Round 8: 1 dc in each st (30 sts).
Round 9: *2 dc in 1 st, 4 dc* to end (36 sts).
Round 10: 1 dc in each st (36 sts).
Round 11: *2 dc in 1 st, 5 dc* to end (42 sts).
Round 12: *2 dc in 1 st, 6 dc* to end (48 sts).
Round 13: 1 dc in each st (48 sts).
Round 14: *2 dc in 1 st, 7 dc* to end (54 sts).
Rounds 15–22: 1 dc in each st (54 sts).
Round 23: *dc2tog, 7 dc* to end (48 sts).
Round 24: 1 dc in each st (48 sts).
Round 25: *dc2tog, 6 dc* to end (42 sts).
Round 26: 1 dc in each st (42 sts).
Round 27: *dc2tog, 5 dc* to end (36 sts).
Round 28: *dc2tog, 4 dc* to end (30 sts).
Round 29: *dc2tog, 3 dc* to end (24 sts). Stuff the head.
Round 30: *dc2tog, 2 dc* to end (18 sts).
Round 31: *dc2tog, 1 dc* to end (12 sts).
Round 32: *dc2tog* to end (6 sts).
Fasten off with a sl st and cut yarn leaving a 20cm (7¾in) tail.
Close up the small hole with a stitch.

LEGS (MAKE TWO)

Using Ivory yarn and a 2.5mm (UK 12, US C/2) hook, make an adjustable ring. This piece is worked in the round.

Round 1: 6 dc in the loop, join with a sl st in first dc, then close the hole by pulling the yarn tail tight (6 sts).
Round 2: 2 dc in each st (12 sts).
Round 3: *2 dc in 1 st, 1 dc* to end (18 sts).
Round 4: 1 dc in back loop only of each st (18 sts).
Rounds 5 and 6: 1 dc in each st (18 sts).
Round 7: *dc2tog, 4 dc* to end (15 sts).
Rounds 8–33: 1 dc in each st (15 sts).
Continue the leg, using Lobelia yarn.
Round 34: 1 dc in each st (15 sts).
Fasten off with a sl st and cut the thread leaving a 10cm (4in) tail.
Make a second identical leg but do not cut yarn.
Continue as follows:
Round 35: work 1 ch. Take the first leg. Point the foot downwards. Join the first leg to the chain with 1 dc, then 2 dc in 1 st, 12 dc, 2 dc in 1 st. You have worked all round the first leg and are back at the chain. 1 dc in front loop only of each ch. You have arrived at the second leg. Continue around second leg working 2 dc in 1 st, 13 dc, 2dc in 1 st. You have arrived at the chain. 1 dc in front loop only of chain. You now have 36 dc. Mark the start of the new round.
Stuff the legs.

Remember: dc = sc in the US

20

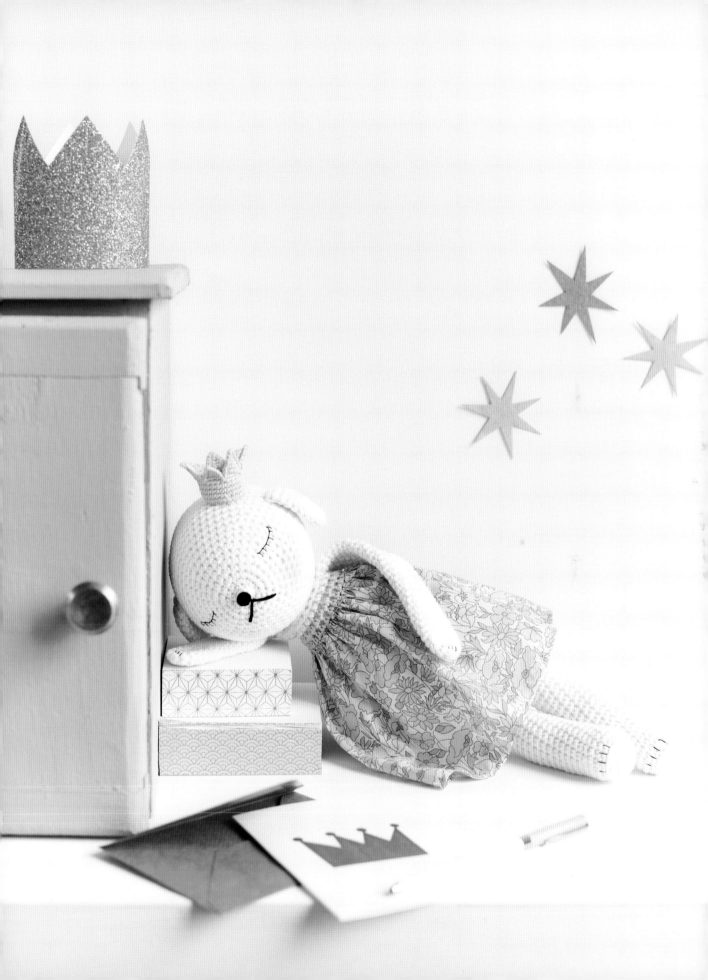

BODY

Rounds 36–51: 1 dc in each st (36 sts).
Round 52: *dc2tog, 4 dc* to end (30 sts).
Rounds 53–56: 1 dc in each st (30 sts).
Round 57: *dc2tog, 3 dc* to end (24 sts).
Continue with Ivory yarn.
Round 58: 1 dc in each st (24 sts).
Stuff the body.
Round 59: *dc2tog, 2 dc* to end (18 sts).
Round 60: 1 dc in each st (18 sts).
Fasten off with a sl st and cut yarn leaving a 40cm (15¾in) tail.

ARMS (MAKE TWO)

Using Ivory yarn and a 2.5mm (UK 12, US C/2) crochet hook,
make an adjustable ring. This piece is worked in the round.
Round 1: 6 dc in the loop, join with a sl st in first dc, then close
the hole by pulling the yarn tail tight (6 sts).
Round 2: 2 dc in each st (12 sts).
Round 3: 2 dc in 1 st, 11 dc (13 sts).
Rounds 4–8: 1 dc in each st (13 sts).
Round 9: dc2tog, 11 dc (12 sts).
Rounds 10–30: 1 dc in each st (12 sts).
Fasten off with a sl st and cut yarn leaving a 30cm (11¾in) tail.
Do not stuff the arms.

EARS (MAKE TWO)

Using Ivory yarn and a 2.5mm (UK 12, US C/2) crochet hook,
make an adjustable ring. This piece is worked in the round.
Round 1: 6 dc in the loop, join with a sl st in first dc, then pull
tight using the tail of yarn (6 sts).
Round 2: 2 dc in each st (12 sts).
Round 3: 1 dc in each st (12 sts).
Round 4: *2 dc in 1 st, 1 dc* to end (18 sts).
Rounds 5–9: 1 dc in each st (18 sts).
Fasten off with a sl st and cut yarn leaving a 35cm (13¾in) tail.
Do not stuff the ears.

**Remember: in the US, dc = sc, htr = hdc,
tr = dc and dtr = tr**

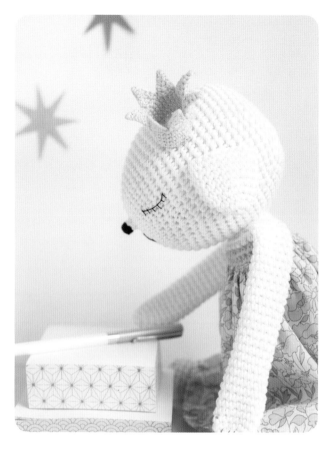

THE CROWN

Work the stitches as tightly as possible so that the crown holds
its shape.
Using Golden Lemon yarn and a 2mm (UK 14, US B/1) crochet
hook, work 28 ch and join with a sl st.
Round 1: 1 dc in each ch (28 sts).
Rounds 2–4: 1 dc in each st (28 sts).
Round 5: start making the first of the seven points by working
a chain which you will then work back down: *7 ch, 1 sl st in
second ch from hook, 1 dc in third ch, 1 htr in fourth, 1 tr in fifth,
1 dtr in sixth, 1 dtr in seventh. You have arrived at the end of the
chain. On the base of the crown, skip 3 dc and join point by 1 sl
st in fourth dc* to end.
Cut yarn, leaving a 45cm (17¾in) tail.

FACE

1. Using the embroidery thread, embroider some delicate eyes. Take your time, this step is all-important in terms of the final result.

2. Using the Noir yarn, embroider the nose and muzzle.

3. Paint the cheeks on to Fleur's face (see page 9).

MAKING UP

1. Sew the ears to the head, placing the right ear a little higher than the left ear.

2. Sew the crown to the head, slightly angled to the left.

3. Sew the head to the body. Attach the arms to the shoulders, a little towards the back of the body.

4. Using the embroidery thread, embroider the claws on the legs and arms.

5. Work in the ends of all the threads.

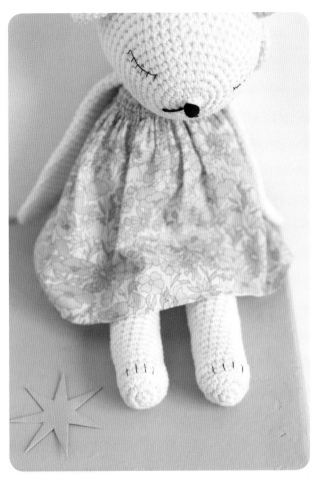

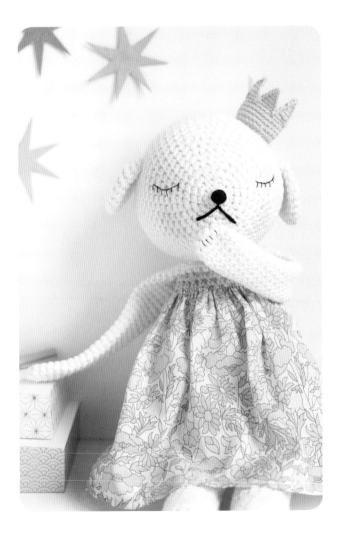

LIBERTY FABRIC SKIRT

1. Fold the fabric right sides together to form a 30 x 14cm (11¾ x 5½in) rectangle. Stitch along the shorter side to create a tube.

2. Sew the hem round the bottom of the skirt.

3. Sew the waistband, through which you will thread the fine elastic: fold back around 1cm (½in) round the top of the skirt and stitch approximately 2mm (1⁄16in) from the edge, leaving an opening of around 0.5cm (¼in) so you can insert the elastic. Using the thick needle, thread the elastic through and secure it with a knot.

4. Dress Princess Fleur in her skirt, allowing two rounds in the Lobelia yarn to show. Distribute the gathers nicely and pin into place. Sew the skirt to the body using tiny slip stitches to hold the gathers in place.

VANIA THE TOMCAT

He might look the picture of innocence, but he can be a real wildcat!

··· MATERIALS ··

* DMC Natura Just Cotton:
 – Ibiza: 30g
 – Glacier: 15g
 – Blue Layette: 15g
 – Blue Jeans: a few strands
* 2.5mm (UK 12, US C/2) crochet hook

* Liberty Farmyard fabric, colour B: 13 x 18cm (5 x 7in)
* Erasable pen
* Elastic thread: 10cm (4in)
* Two orange safety eyes, 6mm in diameter
* Stitch marker

* Black embroidery thread: a few strands
* Red watercolour pencil
* Sewing equipment
* Toy stuffing

FINISHED SIZE: 10 x 28cm (4 x 11in)

HEAD

Using Ibiza yarn, make an adjustable ring (see page 6). This piece is worked in the round.

Round 1: 6 dc in the loop, join with a sl st in first dc, then close the hole by pulling the yarn tail tight (6 sts).

Round 2: 2 dc in each st (12 sts).

Round 3: *2 dc in 1 st, 1 dc* to end (18 sts).

Round 4: *2 dc in 1 st, 2 dc* to end (24 sts).

Round 5: *2 dc in 1 st, 3 dc* to end (30 sts).

Round 6: *2 dc in 1 st, 4 dc* to end (36 sts).

Round 7: *2 dc in 1 st, 5 dc* to end (42 sts).

Round 8: *2 dc in 1 st, 6 dc* to end (48 sts).

Round 9: *2 dc in 1 st, 7 dc* to end (54 sts).

Rounds 10–17: 1 dc in each st (54 sts).

Round 18: *dc2tog, 7 dc* to end (48 sts).

Round 19: *dc2tog, 6 dc* to end (42 sts).

Round 20: *dc2tog, 5 dc* to end (36 sts).

Attach the safety eyes between rounds 14 and 15, spacing them 7 dc apart.

Round 21: *dc2tog, 4 dc* to end (30 sts).

Round 22: *dc2tog, 3 dc* to end (24 sts).

Stuff the head.

Round 23: *dc2tog, 2 dc* to end (18 sts).

Round 24: 2 dc, dc2tog, 4 dc, dc2tog, 4 dc, dc2tog, 2 dc (15 sts).

Round 25: 1 dc in each st (15 sts).

Fasten off with a sl st and cut yarn leaving a 35cm (13¾in) tail.

Close up the small hole with a stitch.

LEGS (MAKE TWO)

Using Ibiza yarn, make an adjustable ring. This piece is worked in the round.

Round 1: 6 dc in the loop, join with a sl st in first dc, then close the hole by pulling the yarn tail tight (6 sts).

Round 2: 2 dc in each st (12 sts).

Rounds 3–21: 1 dc in each st (12 sts).

Continue with Glacier yarn.

Round 22: 1 dc in each st (12 sts).

Fasten off with a sl st and cut yarn leaving a 10cm (4in) tail.

Make a second identical leg without cutting yarn.

Round 23: 2 dc in the second leg. Work 7 ch. Take the first leg. Point the foot downwards. Join the first leg to the chain with 2 dc in 1 st. Work 11 dc round the leg. You are back at the chain; work 1 dc in front loop only of each ch. You have arrived at the second leg. Work 2 dc in 1 st, then 1 dc in each st around this leg. You are back at the chain again. Work 1 dc in front loop only of each ch. You should have 40 dc (13 dc round second leg + 7 dc along chain + 13 dc round first leg + 7 dc back along chain).

Mark the start of the new round.

Stuff the legs.

Remember: dc = sc in the US

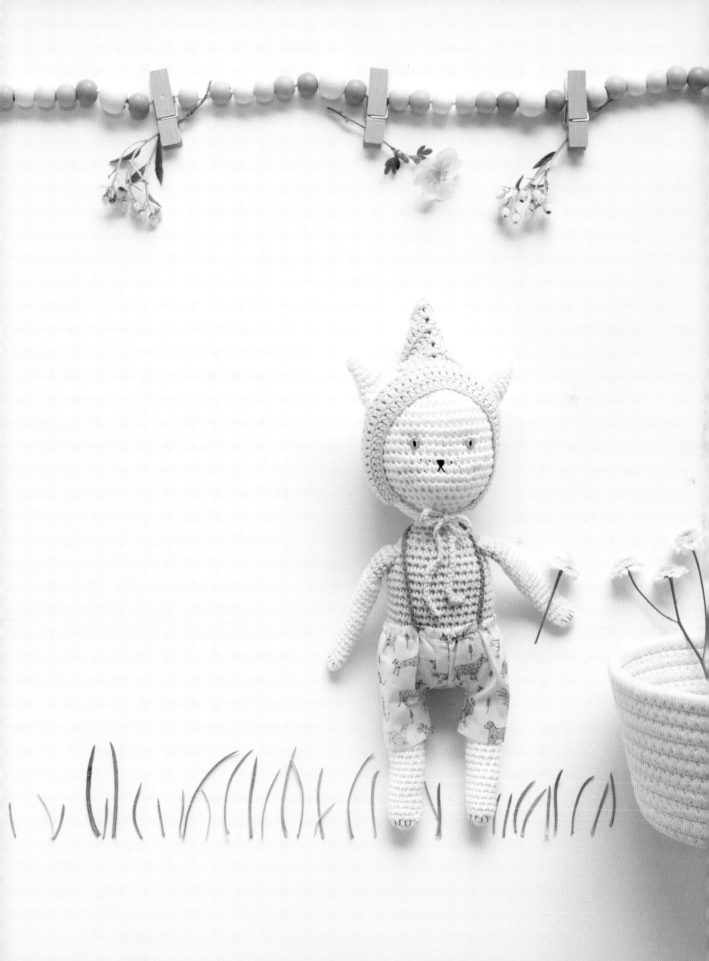

BODY

Rounds 24–38: 1 dc in each st (40 sts).
Round 39: *dc2tog, 5 dc* five times, 5 dc (35 sts).
Rounds 40 and 41: 1 dc in each st (35 sts).
Round 42: *dc2tog, 2 dc, dc2tog, 1 dc* to end (25 sts).
Stuff the body.
Round 43: *dc2tog twice, 1 dc* to end (15 sts).
Round 44: 1 dc in each st (15 sts).
Continue using Ibiza yarn.
Round 45: work 1 dc in each st (15 sts).
Fasten off with a sl st and cut yarn leaving a 40cm (15¾in) tail.

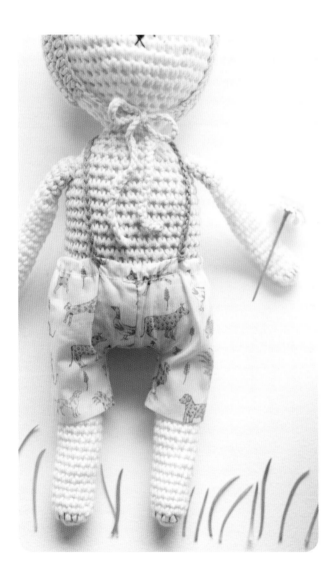

ARMS (MAKE TWO)

Using Ibiza yarn, make an adjustable ring. This piece is worked in the round.
Round 1: 9 dc in the loop, join with a sl st in first dc, then close the hole by pulling the yarn tail tight (9 sts).
Rounds 2–17: 1 dc in each st (9 sts).
Continue using Ibiza yarn.
Round 18: work dc2tog, 7 dc (8 sts).
Rounds 19–21: 1 dc in each st (8 sts).
Fasten off with a sl st and cut yarn leaving a 30cm (11¾in) tail. Stuff the arms very lightly, leaving the top portions empty.

EARS (MAKE TWO)

Using Ibiza yarn, make an adjustable ring. This piece is worked in the round.
Round 1: 5 dc in the loop, join with a sl st in first dc, then close the hole by pulling the yarn tail tight (5 sts).
Round 2: 2 dc in 1 st, 1 dc, 2 dc in 1 st, 2 dc (7 sts).
Round 3: 2 dc in 1 st, 6 dc (8 sts).
Round 4: *2dc in 1 st, 3 dc* to end (10 sts).
Round 5: 2 dc in 1 st, 9 dc (11 sts).
Round 6: 2 dc in 1 st, 5 dc, 2 dc in 1 st, 4 dc (13 sts).
Round 7: 2 dc in 1 st, 12 dc (14 sts).
Round 8: 2 dc in 1 st, 7 dc, 2 dc in 1 st, 5 dc (16 sts).
Round 9: 2 dc in 1 st, 15 dc (17 sts).
Fasten off with a sl st and cut yarn, leaving a 40cm (15¾in) tail. Stuff lightly.

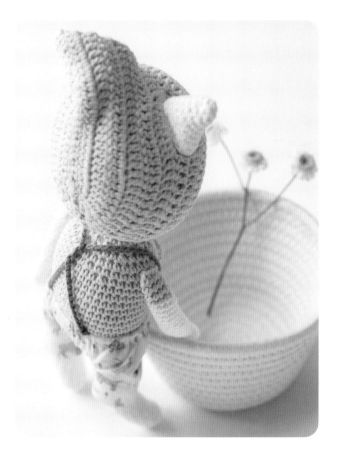

Fasten off and cut yarn, leaving a long tail end to be woven in later. Fold the bonnet in two so the holes for the ears are on top of each other. Using Blue Layette yarn, sew up the back of the bonnet. Work two chains of 45 ch each and sew them to the bonnet at the neck. Weave in all loose ends.

FABRIC SHORTS

1. Fold the fabric right sides together to form a 6.5 x 18cm (2½ x 7in) rectangle. Position with the fold to the right and the open side to the left. Trace the template for the shorts (page 62) twice on to the fabric, adding a 0.5cm (¼in) seam allowance around each template.
2. Cut out the pieces from the fabric. Open them out and with right sides together, sew the front central seam, then the back seam.
3. Sew round the crotch. Hem the legs.
4. Hem around the waist, but leave a little opening through which you can thread the elastic.
5. Cut the elastic so it fits round the cat's waist, thread through waist hem and join together with a small stitch. Finish the waist hem, completely encasing the elastic.
6. Using Blue Jeans yarn, work two chains each of 40 ch. Attach them to the front of the shorts, cross them over at the back and sew them on to the back of the shorts.

MAKING UP

1. Sew the head to the body.
2. Place the bonnet on the head and attach the ears, positioning them in the middle of the openings.
3. Fix the arms to the sides of the body, three rounds below the head.
4. Using the embroidery thread, embroider a little nose and the mouth, then three small dots on either side of the nose to represent whiskers. Using the same thread, embroider the claws on the legs and arms.
5. Tie on the bonnet and slip him into his shorts.
6. Paint the cheeks on to Vania's face (see page 9).

Remember: tr = dc in the US

BONNET

Using Blue Layette yarn, work 49 ch. This piece is worked in rows.

Row 1: 1 tr in fourth ch from hook, then 1 tr in each ch to end (47 sts).

Rows 2 and 3: 3 ch, 46 tr (47 sts).

Row 4: 3 ch, 12 tr, 8 ch, skip 7 tr, 3 dc (this will be the ear hole). [1 tr, 1 ch, 1 dc] in next st (these increases and those in the next rows will form the point of the bonnet). Then 3 tr, 8 ch, skip 7 dc, 13 tr.

Row 5: 3 ch, 12 tr, 8 tr in each ch, 4 dc, [1 tr, 1 ch, 1 tr] in ch sp, 4 dc, 8 tr in each ch, 13 tr.

Row 6: 3 ch, 25 tr, [1 tr, 1 ch, 1 tr] in ch sp, 26 tr.

Row 7: 3 ch, tr2tog, 24 tr. [1 tr, 1 ch, 1 tr] in ch sp, 24 tr, tr2tog, 1 tr.

Row 8: 3 ch, tr2tog, tr2tog, 22 dc, [1 tr, 1 ch, 1 tr] in ch sp, 22 tr, tr2tog, tr2tog, 1 tr.

Row 9: 3 ch, tr2tog, tr2tog, 21 dc, [1 tr, 1 ch, 1 tr] in ch sp, 21 tr, tr2tog, tr2tog, 1 tr.

Row 10: 3 ch, tr2tog, tr2tog, 20 dc, [1 tr, 1 ch, 1 tr] in ch sp, 20 tr, tr2tog, tr2tog, 1 tr.

ALBERT AND ANNA

A globetrotting couple who travel the world in search of new adventures.

MATERIALS

* DMC Spécial Dentelle:
 – White: a few strands
* 2mm (UK 14, US B/1) and 2.5mm (UK 12, US C/2) crochet hooks
* Stitch marker
* Four black safety eyes, 4mm in diameter
* Sewing equipment
* Black embroidery thread: a few strands
* Toy stuffing

ALBERT (FINISHED SIZE: 30 X 10CM (11¾ X 4IN))
* DMC Natura Just Cotton:
 – Blue Night: 10g
 – Bourgogne: 10g
 – Giroflée: a few strands
 – Sable: 15g
* Liberty Betsy Ann fabric, red 28 x 2cm (11 x ¾in)

ANNA (FINISHED SIZE: 26 X 13CM (10¼ X 5IN))
* DMC Natura Just Cotton:
 – Blue Night: 10g
 – Bourgogne: 5g
 – Giroflée: 15g
 – Nacar: 15g
 – Jade: 10g
* Liberty Claire-Aude fabric, colour A: 24 x 6cm (9½ x 2¼in)

ALBERT'S LOWER BODY

Using Giroflée yarn and a 2.5mm (UK 12, US C/2) hook, work an adjustable ring (see page 6). This piece is worked in the round.
Round 1: 7 dc in the loop, join with a sl st in first dc, then close the hole by pulling the yarn tail tight (7 sts).
Round 2: 2 dc in each st (14 sts).
Round 3: 2 dc in 1 st, 13 dc (15 sts).
Rounds 4 and 5: 1 dc in each st (15 sts).
Continue with Bourgogne yarn.
Rounds 6–29: 1 dc in each st (15 sts).
Fasten off with a sl st and cut yarn leaving a 10cm (4in) tail.
Make a second identical leg but do not cut yarn.
Round 30: 3 dc on same leg, 9 ch. Take the first leg. Point the foot downwards. Join the first leg to the chain with 1 dc, work 14 dc. You have worked all round the first leg. Work 9 dc in front loop only of chain, 15 dc round second leg, 9 dc in front loop only of chain. You should have 48 sts (15 dc round first leg + 9 dc along chain + 15 dc round second leg + 9 dc back along chain. Mark the start of the new round.
Rounds 31–37: 1 dc in each st (48 sts).
Do not cut yarn.
Stuff the lower body.

ALBERT'S UPPER BODY

Using Sable yarn and a 2.5mm (UK 12, US C/2) hook, work an adjustable ring. This piece is worked in the round.
Round 1: 6 dc in the loop, join with a sl st in first dc, then close the hole by pulling the yarn tail tight (6 sts).
Round 2: 2 dc in each st (12 sts).
Round 3: *2 dc in 1 st three times, 3 dc* to end (18 sts).
Round 4: 2 dc, *2 dc in 1 st* three times, 6 dc, *2 dc in 1 st* three times, 4 dc (24 sts).
Round 5: 4 dc, *2 dc in 1 st* three times, 9 dc, *2 dc in 1 st* three times, 5 dc (30 sts).
Round 6: 6 dc, *2 dc in 1 st* three times, 12 dc, *2 dc in 1 st* three times, 6 dc (36 sts).
Round 7: 8 dc, *2 dc in 1 st* three times, 15 dc, *2 dc in 1 st* three times, 7 dc (42 sts).
Round 8: 1 dc in each st (42 sts).
Round 9: 9 dc, *2 dc in 1 st* three times, 18 dc, *2 dc in 1 st* three times, 9 dc (48 sts).
Rounds 10–24: 1 dc in each st (48 sts).
Continue with Night Blue yarn.
Rounds 25–45: 1 dc in each st (48 sts).
Fasten off with a sl st and cut yarn leaving a 15cm (6in) tail.
Attach the safety eyes between rounds 15 and 16, spacing them 14 dc apart.
Stuff the upper body.

Remember: dc = sc in the US

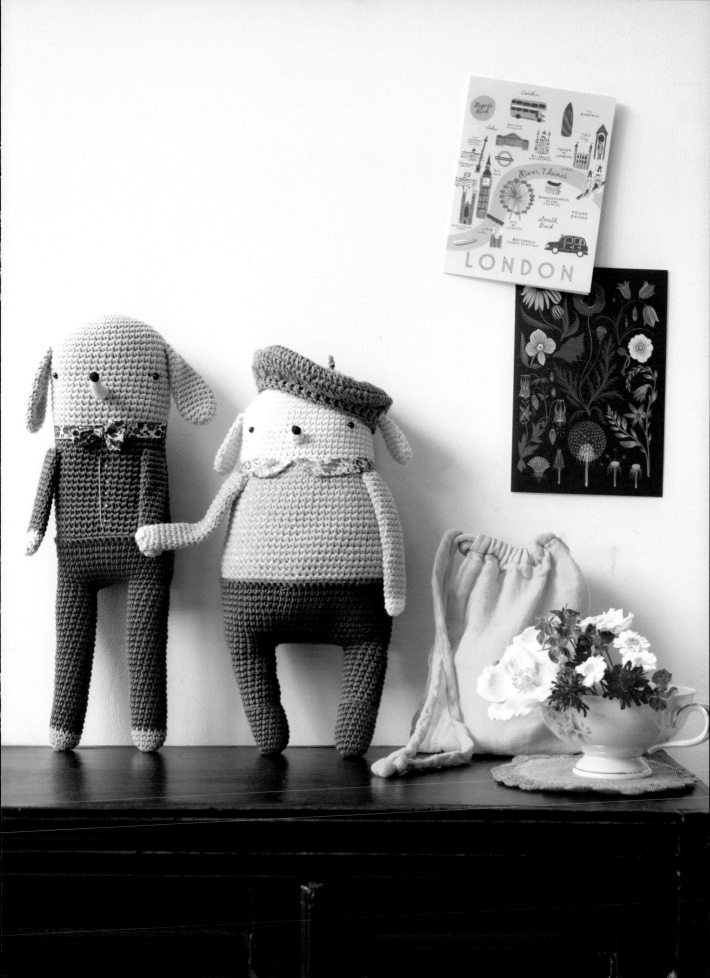

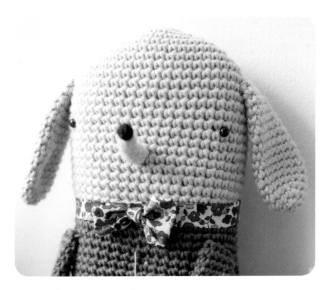

ARMS (MAKE TWO)

Using Sable yarn and a 2.5mm (UK 12, US C/2) hook, make an adjustable ring. This piece is worked in the round.
Round 1: 10 dc in the loop, join with a sl st in first dc, then close the hole by pulling the yarn tail tight (10 sts).
Round 2: 2 dc in 1 st, 9 dc (11 sts).
Rounds 3 and 4: 1 dc in each st (11 sts).
Continue with Night Blue yarn.
Round 5: dc2tog, 9 dc (10 sts).
Rounds 6–19: 1 dc in each st (10 sts).
Fasten off with a sl st and cut yarn leaving a 20cm (7¾in) tail. Do not stuff the arms.

EARS (MAKE TWO)

Using Sable yarn and a 2.5mm (UK 12, US C/2) hook, work an adjustable ring. This piece is worked in the round.
Round 1: 8 dc in the loop, join with a sl st in first dc, then close the hole by pulling the yarn tail tight (8 sts).
Round 2: *2 dc in 1 st, 1 dc* to end (12 sts).
Round 3: *2 dc in 1 st, 2 dc* to end (16 sts).
Rounds 4–6: 1 dc in each st (16 sts).
Round 7: dc2tog, 14 dc (15 sts).
Round 8: 1 dc in each st (15 sts).
Round 9: dc2tog, 13 dc (14 sts).
Round 10: 1 dc in each st (14 sts).
Round 11: dc2tog, 12 dc (13 sts).
Round 12: 1 dc in each st (13 sts).
Round 13: dc2tog, 11 dc (12 sts).
Round 14: 1 dc in each st (12 sts).
Round 15: dc2tog, 10 dc (11 sts).
Round 16: 1 dc in each st (11 sts).
Fasten off with a sl st and cut yarn leaving a 30cm (11¾in) tail. Do not stuff the ears.

NOSE

Using Sable yarn and a 2mm (UK 14, US B/1) crochet hook, make an adjustable ring. This piece is worked in the round.
Round 1: 4 dc in the loop, join with a sl st in first dc, then close the hole by pulling the yarn tail tight (4 sts).
Round 2: 1 dc in each st (4 sts).
Round 3: 2 dc in 1 st, 3 dc (5 sts).
Round 4: 1 dc in each st (5 sts).
Round 5: 2 dc in 1 st, 4 dc (6 sts).
Round 6: 1 dc in each st (6 sts).
Round 7: 2 dc in 1 st, 5 dc (7 sts).
Round 8: 1 dc in each st (7 sts).
Fasten off with a sl st and cut yarn leaving a 25cm (9¾in) tail. Stuff the nose.

MAKING UP

1. Attach the upper and lower body together using the Bourgogne yarn, as follows:
2. Place the two parts of the body with the head towards you and legs away from you. Join using Bourgogne yarn. Pass the hook through the strands of the top sts and the strands of the bottom sts and work 1 dc. Repeat for the remaining 47 stitches.
3. Fasten off with a sl st and cut yarn leaving a 15cm (6in) tail.
4. Sew the arms towards the front of the body at round 32. Sew the ears to the sides of the head and the nose on to the head, three or four rounds under the eyes.
5. Using the embroidery thread, embroider the point of the nose, forming a little ball.
6. Using White yarn, embroider a vertical line and five little dots on to the shirt to look like a shirt front and buttons.

FABRIC BOW TIE

1. Use an offcut of Liberty fabric (here I have used Betsy Ann red) or a different fabric if you prefer. Cut two strips 24 x 2cm (9½ x ¾in) and 4 x 2cm (1½ x ¾in).
2. On the longer strip, fold (wrong side to wrong side) 0.5cm (¼in) towards the middle at the top and the bottom to get a band that is 1cm (½in) high and 24cm (9½in) long. Fold in the middle to get a long narrow band that is 0.5cm (¼in) high and iron. Sew into place around the neck.
3. With the small remaining rectangle, fold the edges to the middle to get a rectangle approximately 3 x 1.5cm (1¼ x ½in). Pinch the rectangle in the middle to make a bow shape and stitch to hold in place.
4. Fix the bow on to the band, just under the chin.

ANNA'S LOWER BODY

Using Bourgogne yarn and a 2.5mm (UK 12, US C/2) hook, make an adjustable ring. This piece is worked in the round.

Round 1: 8 dc in the loop, join with a sl st in first dc, then close the hole by pulling the yarn tail tight (8 sts).

Round 2: 2 dc in each st (16 sts).

Rounds 3–10: 1 dc in each st (16 sts).

Continue with Night Blue yarn.

Round 11 (back loop only): 1 dc in each st (16 sts).

Rounds 12–20: 1 dc in each st (16 sts).

Fasten off with a sl st and cut yarn leaving a 10cm (4in) tail. Make a second identical leg but do not cut yarn.

Round 21: 3 dc, 12 ch. Take the first leg. Point the foot downwards. Join first leg to chain with 1 dc, work 15 dc. You have worked all round the first leg. Work 12 dc in front loop only of chain, 16 dc around second leg, 12 dc in front loop of chain. You should have 56 sts (16 dc round first leg + 12 dc along chain + 16 dc round second leg + 12 dc back along chain. Mark the start of the new round.

Round 22: *2 dc in 1 st, 13 dc* to end (60 sts).

Round 23: *2 dc in 1 st, 14 dc* to end (64 sts).

Round 24: 1 dc in each st (64 sts).

Round 25: *2 dc in 1 st, 15 dc* to end (68 sts).

Rounds 26 and 27: 1 dc in each st (68 sts).

Round 28: *2 dc in 1 st, 16 dc* to end (72 sts).

Do not cut yarn.

Stuff the lower body.

ANNA'S UPPER BODY

Using Nacar yarn and a 2.5mm (UK 12, US C/2) hook, make an adjustable ring. This piece is worked in the round.

Round 1: 8 dc in the loop, join with a sl st in first dc, then close the hole by pulling the yarn tail tight (8 sts).

Round 2: 2 dc in each st (16 sts).

Round 3: 2 dc, *2 dc in 1 st* four times, 4 dc, *2 dc in 1 st* four times, 2 dc (24 sts).

Round 4: 4 dc, *2 dc in 1 st* four times, 8 dc, *2 dc in 1 st* four times, 4 dc (32 sts).

Round 5: 8 dc, *2 dc in 1 st* four times, 8 dc, *2 dc in 1 st* four times, 8 dc (40 sts).

Round 6: 10 dc, *2 dc in 1 st* four times, 16 dc, *2 dc in 1 st* four times, 6 dc (48 sts).

Rounds 7 and 8: 1 dc in each st (48 sts).

Round 9: 12 dc, *2 dc in 1 st* four times, 20 dc, *2 dc in 1 st* four times, 8 dc (56 sts).

Rounds 10–20: 1 dc in each st (56 sts).

Continue with Giroflée and white yarn doubled to obtain the speckled effect of the blouse. Work 2 dc then mark the start of the new round.

Round 21: *2 dc in 1 st, 13 dc* to end (60 sts).

Rounds 22–25: 1 dc in each st (60 sts).

Round 26: 7 dc, *2 dc in 1 st, 14 dc* three times, then 2 dc in 1 st, 7 dc (64 sts).

Rounds 27–30: 1 dc in each st (64 sts).

Round 31: *2 dc in 1 st, 15 dc* to end (68 sts).

Rounds 32–34: 1 dc in each st (68 sts).

Round 35: 8 dc, *2 dc in 1 st, 16 dc* three times, then 2 dc in 1 st, 8 dc (72 sts).

Rounds 36–39: 1 dc in each st (72 sts).

Fasten off with a sl st and cut yarn leaving a 15cm (6in) tail.

Attach the safety eyes between rounds 14 and 15, spacing them 16 dc apart.

Stuff the upper body.

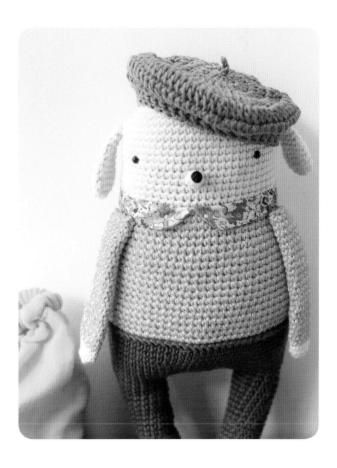

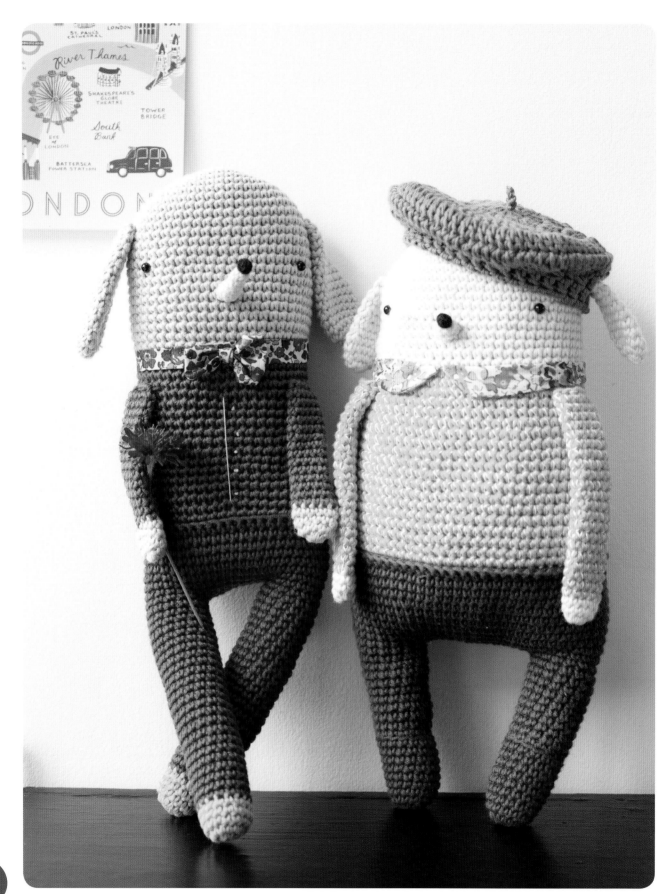

ARMS (MAKE TWO)

Using Nacar yarn and a 2.5mm (UK 12, US C/2) hook, make an adjustable ring. This piece is worked in the round.

Round 1: 10 dc in the loop, join with a sl st in first dc, then close the hole by pulling the yarn tail tight (10 sts).

Rounds 2 and 3: 1 dc in each st (10 sts).

Continue with Giroflée yarn doubled with white yarn.

Rounds 4–23: 1 dc in each st (10 sts).

Fasten off with a sl st and cut yarn leaving a 20cm (7¾in) tail. Do not stuff the arms.

EARS (MAKE TWO)

Using Nacar yarn and a 2.5mm (UK 12, US C/2) hook, make an adjustable ring. This piece is worked in the round.

Round 1: 6 dc in the loop, join with a sl st in first dc, then close the hole by pulling the yarn tail tight (6 sts).

Round 2: 2 dc in each st (12 sts).

Rounds 3 and 4: 1 dc in each st (12 sts).

Round 5: *dc2tog, 4 dc* to end (10 sts).

Rounds 6 and 7: 1 dc in each st (10 sts).

Round 8: *dc2tog, 3 dc* to end (8 sts).

Rounds 9–11: 1 dc in each st (8 sts).

Fasten off with a sl st and cut yarn leaving a 30cm (11¾in) tail. Do not stuff the ears.

NOSE

Using Nacar yarn and a 2mm (UK 14, US B/1) crochet hook, make an adjustable ring. This piece is worked in the round.

Round 1: 4 dc in the loop, join with a sl st in first dc, then close the hole by pulling the yarn tail tight (4 sts).

Round 2: *2dc in 1 st, 1 dc* to end (6 sts).

Fasten off with a sl st and cut yarn leaving a 25cm (9¾in) tail. Stuff the nose.

BERET

Using Jade yarn and 2.5mm (UK 12, US C/2) crochet hook, make an adjustable ring. This piece is worked in the round.

Round 1: 3 ch (this counts as the first tr, 9 tr in the loop, join with a sl st in first dc, then close the hole by pulling the yarn tail tight (10 sts).

Round 2: 3 ch, 1 tr in sl st of previous round, *2 tr in each st* to end (20 sts).

Round 3: 3 ch, 2 tr in 1st, *1 tr, 2 tr in next st* to end (30 sts).

Round 4: 3 ch, 1 tr, 2 tr in 1st, *2 tr, 2 tr in next st* to end (40 sts).

Round 5: 3 ch, 2 tr, 2 tr in 1st, *3 tr, 2 tr in 1st* to end (50 sts).

Round 6: 3 ch, 3 tr, 2 tr in 1 st, *4 tr, 2 tr in 1 st* to end (60 sts).

Round 7: 3 ch, tr2tog, *1 tr, tr2tog* to end (40 sts).

Rounds 8 and 9: 3 ch, 39 tr (40 sts).

Rounds 10 and 11: 1 dc in each st (40 sts).

Fasten off with a sl st and cut yarn leaving a 25cm (9¾in) tail.

MAKING UP

1. To make up Anna, follow the instructions for Albert, but sew the arms to the body at round 22 and do not embroider the shirt front.

2. Place the beret on her head, passing her left ear between 2 tr.

FABRIC PETER PAN COLLAR

1. Fold the fabric right sides together to form a 12 x 6cm (4¾ x 2¼in) rectangle. Trace the template for the collar (see page 63) on to the fabric twice, adding a 0.5cm (¼in) seam allowance, and cut out.

2. Sew up the two halves of the collar on a sewing machine or by hand, leaving a 2cm (¾in) opening. Turn the right way out. Sew up the opening by hand.

3. Pin the collar to Anna's blouse between rows 20 and 21 and stitch into place using invisible stitches.

Remember: tr = dc in the US

MIKKI THE HEDGEHOG

A hedgehog that is not the slightest bit prickly ~ did you ever see such a thing?
This project is easy, but take care to work the right number of stitches.

···· MATERIALS ··

* DMC Natura Just Cotton:
 – Agatha: 50g
 – Star Light: 15g
 – Blue Jeans: 15g
 – Crimson: 15g
 – Coral: 15g
– Turquoise: 15g
– Prune: 15g
– Black: a few strands
* 2.5mm (UK 12, US C/2) crochet hook
* Stitch marker
* Liberty Edenham fabric, colour J: 16 x 20cm (6¼ x 7¾in)
* Two black safety eyes, 4mm in diameter
* Sewing equipment
* Toy stuffing
* Erasable pen

FINISHED SIZE: 15 x 25cm (6 x 9¾in)

BODY

Using Agatha yarn, work an adjustable ring (see page 6). This piece is worked in the round.

Round 1: 6 dc in the loop, join with a sl st in first dc, then close the hole by pulling the yarn tail tight (6 sts).

Round 2: *2 dc in 1 st, 1 dc* to end (9 sts).

Round 3: 2 dc in 1 st, 8 dc (10 sts).

Round 4: 1 dc, 2 dc in 1 st, 8 dc (11 sts).

Round 5: 2 dc, 2 dc in 1 st, 8 dc (12 sts).

Round 6: 3 dc, 2 dc in 1 st, 8 dc (13 sts).

Round 7: 3 dc, 2 dc in 1 st, 1 dc, 2 dc in 1 st, 7 dc (15 sts).

Round 8: 4 dc, 2 dc in 1 st, 1 dc, 2 dc in 1 st, 8 dc (17 sts).

Round 9: 1 dc, 2 dc in 1 st, 2 dc, 2 dc in 1 st, 2 dc, 2 dc in 1 st, 3 dc, 2 dc in 1 st, 5 dc (21 sts).

Round 10: 4 dc, 2 dc in 1 st, 2 dc, 2 dc in 1 st, 3 dc, 2 dc in 1 st, 2 dc, 2 dc in 1 st, 6 dc (25 sts).

Round 11: 1 dc in each st (25 sts).

Round 12: 6 dc, 2 dc in 1 st, 2 dc, 2 dc in 1 st, 4 dc, 2 dc in 1 st, 2 dc, 2 dc in 1 st, 7 dc (29 sts).

Round 13: 8 dc, 2 dc in 1 st, 3 dc, 2 dc in 1 st, 3 dc, 2 dc in 1 st, 3 dc, 2 dc in 1 st, 8 dc (33 sts).

Round 14: 10 dc, 2 dc in 1 st, 3 dc, 2 dc in 1 st, 4 dc, 2 dc in 1 st, 3 dc, 2 dc in 1 st, 9 dc (37 sts).

Round 15: 1 dc in each st (37 sts).

Round 16: 11 dc, 2 dc in 1 st, 4 dc, 2 dc in 1 st, 5 dc, 2 dc in 1 st, 4 dc, 2 dc in 1 st, 9 dc (41 sts).

Round 17: 12 dc, 2 dc in 1 st, 5 dc, 2 dc in 1 st, 6 dc, 2 dc in 1 st, 5 dc, 2 dc in 1 st, 9 dc (45 sts).

Round 18: 13 dc, 2 dc in 1 st, 6 dc, 2 dc in 1 st, 7 dc, 2 dc in 1 st, 6 dc, 2 dc in 1 st, 9 dc (49 sts).

Round 19: 1 dc in each st (49 sts).

Round 20: 14 dc, 2 dc in 1 st, 7 dc, 2 dc in 1 st, 8 dc, 2 dc in 1 st, 7 dc, 2 dc in 1 st, 9 dc (53 sts).

Round 21: 15 dc, 2 dc in 1 st, 8 dc, 2 dc in 1 st, 9 dc, 2 dc in 1 st, 8 dc, 2 dc in 1 st, 9 dc (57 sts).

Round 22: 16 dc, 2 dc in 1 st, 9 dc, 2 dc in 1 st, 10 dc, 2 dc in 1 st, 9 dc, 2 dc in 1 st, 9 dc (61 sts).

Round 23: 1 dc in each st (61 sts).

Round 24: 17 dc, 2 dc in 1 st, 10 dc, 2 dc in 1 st, 11 dc, 2 dc in 1 st, 10 dc, 2 dc in 1 st, 9 dc (65 sts).

Round 25: 18 dc, 2 dc in 1 st, 11 dc, 2 dc in 1 st, 12 dc, 2 dc in 1 st, 11 dc, 2 dc in 1 st, 9 dc (69 sts).

Round 26: 18 dc, 2 dc in 1 st, 12 dc, 2 dc in 1 st, 13 dc, 2 dc in 1 st, 12 dc, 2 dc in 1 st, 10 dc (73 sts).

Round 27: 1 dc in each st (73 sts).

Round 28: 18 dc, 2 dc in 1 st, 13 dc, 2 dc in 1 st, 14 dc, 2 dc in 1 st, 13 dc, 2 dc in 1 st, 11 dc (77 sts).

Round 29: 1 dc in each st (77 sts).

Round 30: 19 dc, 2 dc in 1 st, 14 dc, 2 dc in 1 st, 15 dc, 2 dc in 1 st, 14 dc, 2 dc in 1 st, 11 dc (81 sts).

Rounds 31–46: 1 dc in each st (81 sts).

Round 47: *dc2tog, 7 dc* to end (72 sts).

Rounds 48 and 49: 1 dc in each st (72 sts).

Round 50: *dc2tog, 6 dc* to end (63 sts).

Rounds 51 and 52: 1 dc in each st (63 sts).

Round 53: *dc2tog, 5 dc* to end (54 sts).

Round 54: 1 dc in each st (54 sts).

Round 55: *dc2tog, 4 dc* to end (45 sts).

Round 56: 1 dc in each st (45 sts).

Attach the safety eyes between rounds 15 and 16, spaced 18 dc apart.

Remember: dc = sc in the US

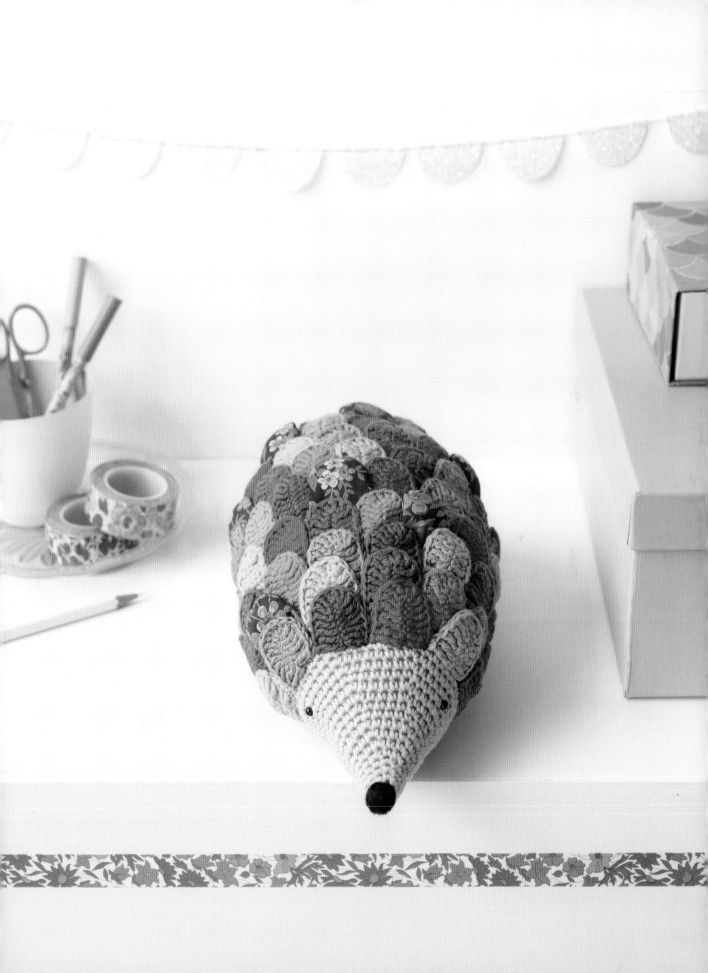

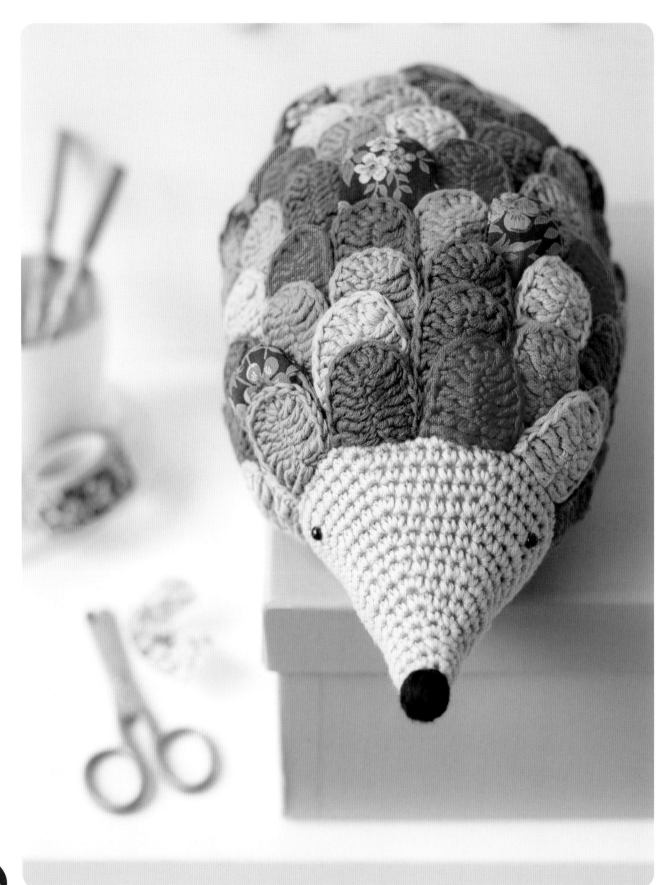

Stuff the body.

Round 57: *dc2tog, 3 dc* to end (36 sts).
Round 58: *dc2tog, 2 dc* to end (27 sts).
Round 59: *dc2tog, 1 dc* to end (18 sts).
Round 60: *dc2tog* to end (9 sts).

Fasten off with a sl st and cut yarn leaving a 15cm (6in) tail. Close up the small hole with a stitch. Work in end of yarn.

CROCHETED SPIKES

Make eight each in Star Light, Blue Jeans, Crimson, Coral, Turquoise and Prune.

Work 10 ch. Work dtr in front loop of fourth ch from hook, then dtr in front loop of next 6 ch, 3 tr in last ch. Continue by working back down the chain: work 7 dtr in front loop of each st.

Cut yarn, leaving a 25cm (9¾in) tail and fasten off.

FABRIC SPIKES

1. On the reverse side, trace the template for the spike (see page 63) sixteen times, adding a 0.5cm (¼in) seam allowance, and cut out.
2. Lay two spikes right sides together and sew round them using a sewing machine or by hand, leaving a 2cm (¾in) opening.
3. Turn the spike the right way out and stuff lightly.
4. Sew up the opening by hand.

MAKING UP

1. Using the Noir yarn, embroider the nose, making it into the shape of a little ball.
2. Pin all the spikes in horizontal rows on the hedgehog's body, alternating colours and mixing in the Liberty print spikes. The spikes begin at round 18.
3. When you are happy with the arrangement of the spikes, sew them to the body, one by one, starting at the back and working forwards towards the head. Note: you also need to ensure that the curved parts of the spikes are sewn down otherwise they may curl up, giving a less attractive finish. This stage is time-consuming, but is important if you want to achieve a good end result!

Remember: in the US, tr = dc and dtr = tr

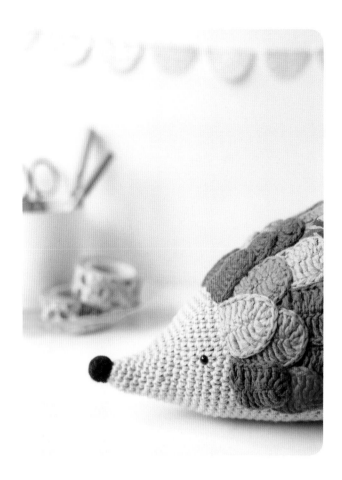

- Tip -

Do not aim for symmetry with the spikes – a random arrangement is more attractive and more natural-looking!

JACQUES, A MOST UNUSUAL GOAT

Jacques is a noble creature who lives in Paris,
in a beautiful apartment overlooking the Luxembourg Gardens.

MATERIALS

* DMC Natura Just Cotton:
 – Ibiza: 25g
 – Ivory: 15g
 – Gardenia: 5g
* 2.5mm (UK 12, US C/2) crochet hook
* Stitch marker
* Liberty Betsy fabric, Porcelain: 3 x 3cm (1¼ x 1¼in)
* Two black safety eyes, 6mm in diameter
* Black embroidery thread: a small amount
* Sewing equipment
* Toy stuffing

FINISHED SIZE: 10 x 21cm (4 x 8¼in)

HEAD

Using Ivory yarn, make an adjustable ring (see page 6). This piece is worked in the round.

Round 1: 6 dc in the loop, join with a sl st in first dc, then close the hole by pulling the yarn tail tight (6 sts).

Round 2: 2 dc in each st (12 sts).

Round 3: *2 dc in 1 st, 1 dc* to end (18 sts).

Round 4: *2 dc in 1 st, 2 dc* to end (24 sts).

Round 5: *2 dc in 1 st, 3 dc* to end (30 sts).

Round 6: *2 dc in 1 st, 4 dc* to end (36 sts).

Round 7: *2 dc in 1 st, 5 dc* to end (42 sts).

Round 8: *2 dc in 1 st, 6 dc* to end (48 sts).

Round 9: *2 dc in 1 st, 7 dc* to end (54 sts).

Round 10: *2 dc in 1 st, 8 dc* to end (60 sts).

Round 11: *2 dc in 1 st, 9 dc* to end (66 sts).

Rounds 12–20: 1 dc in each st (66 sts).

Round 21: *dc2tog, 9 dc* to end (60 sts).

Round 22: *dc2tog, 8 dc* to end (54 sts).

Round 23: *dc2tog, 7 dc* to end (48 sts).

Round 24: *dc2tog, 6 dc* to end (42 sts).

Round 25: *dc2tog, 5 dc* to end (36 sts).

Round 26: *dc2tog, 4 dc* to end (30 sts).

Round 27: *dc2tog, 3 dc* to end (24 sts).

Attach the safety eyes between rounds 19 and 20, 17 sts apart. Stuff the head.

Round 28: *dc2tog, 2 dc* to end (18 sts).

Fasten off with a sl st and cut yarn leaving a 15cm (6in) tail. Work in end of yarn.

MUZZLE

Using Gardenia yarn, make an adjustable ring. This piece is worked in the round.

Round 1: 6 dc in the loop, join with a sl st in first dc, then close the hole by pulling the yarn tail tight (6 sts).

Round 2: *2dc in 1 st, 2 dc* to end (8 sts).

Round 3: *2dc in 1 st, 2 dc in 1 st, 2 dc* to end (12 sts).

Round 4: *2dc in 1 st, 2 dc in 1 st, 4 dc* to end (16 sts).

Fasten off with a sl st and cut yarn leaving a 30cm (11¾in) tail.

LEGS (MAKE TWO)

Using Ibiza yarn, make an adjustable ring. This piece is worked in the round.

Round 1: 6 dc in the loop, join with a sl st in first dc, then close the hole by pulling the yarn tail tight (6 sts).

Round 2: 2 dc in each st (12 sts).

Round 3: *2 dc in 1 st, 1 dc* to end (18 sts).

Rounds 4–10: 1 dc in each st (18 sts).

Round 11: *2dc in 1 st, 8 dc* to end (20 sts).

Fasten off with a sl st and cut yarn leaving a 10cm (4in) yarn tail. Make a second identical leg but do not cut yarn.

Remember: dc = sc in the US

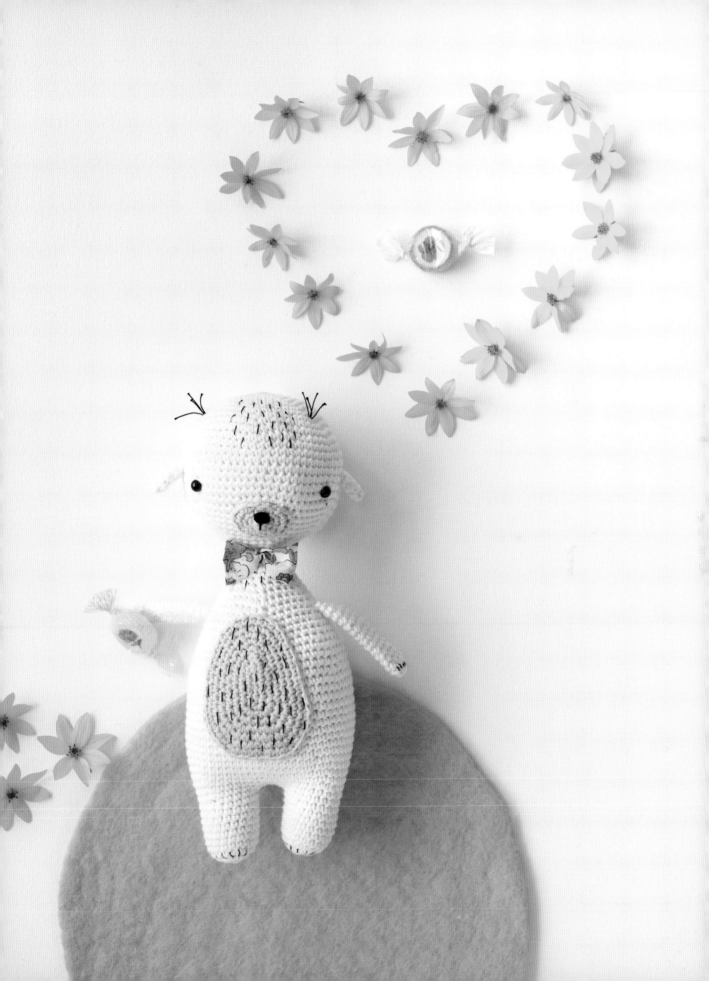

Round 12: Work 3 ch. Take the first leg. Point the foot downwards. Join the first leg to the chain with 1 dc, then work 19 dc. You should have worked all the way round the first leg and be back at the chain. 1 dc in front loop only of each ch. You have arrived at the second leg. Continue around second leg, working 1 dc in each st. You are back at the chain. 1 dc in front loop only of each ch. You should have 46 dc (20 dc round first leg + 3 dc along chain + 20 dc round second leg + 3 dc back along chain. Mark the start of the new round.
Stuff the legs.

BODY

Round 13: 2 dc in 1 st, 6 dc, 2 dc in 1 st, 6 dc, 2 dc in 1 st, 12 dc, 2 dc in 1 st, 18 dc (50 sts).
Round 14: 2 dc in 1 st, 7 dc, 2 dc in 1 st, 7 dc, 2 dc in 1 st, 33 dc (53 sts).
Round 15: 28 dc, 2 dc in 1 st, 8 dc, 2 dc in 1 st, 8 dc, 2 dc in 1 st, 6 dc (56 sts).
Round 16: 2 dc in 1 st, 8 dc, 2 dc in 1 st, 8 dc, 2 dc in 1 st, 36 dc, 2 dc in 1 st (60 sts).
Rounds 17–26: 1 dc in each st (60 sts).
Round 27: *dc2tog, 8 dc* to end (54 sts).
Rounds 28–30: 1 dc in each st (54 sts).
Round 31: *dc2tog, 7 dc* to end (48 sts).
Rounds 32 and 33: 1 dc in each st (48 sts).
Round 34: *dc2tog, 6 dc* to end (42 sts).
Round 35: 1 dc in each st (42 sts).
Round 36: *dc2tog, 5 dc* to end (36 sts).
Round 37: 1 dc in each st (36 sts).
Round 38: *dc2tog, 4 dc* to end (30 sts).
Round 39: *dc2tog, 3 dc* to end (24 sts).
Stuff the body.
Round 40: *dc2tog, 2 dc* to end (18 sts).
Rounds 41–44: 1 dc in each st (18 sts).
Fasten off with a sl st and cut yarn leaving a 35cm (13¾in) tail.

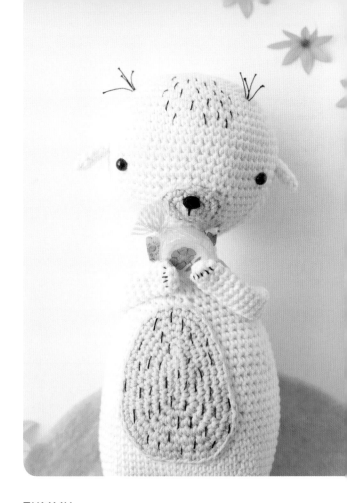

TUMMY

Using Gardenia yarn, work 6 ch. This piece is worked in the round, around the chain.
Round 1: 1 dc in front loop only of second ch from the hook, 1 dc in front loop only of next 3 ch, 3 dc in last ch. You have arrived at the end of the chain. Now go back along other side: 4 dc in front loop only of next 4 ch, 3 dc in last ch (14 sts).
Round 2: 5 dc, 4 dc in 1 st, 6 dc, 2 dc in 1 st, 1 dc (18 sts).
Round 3: 5 dc, *2 dc in 1 st* four times, 6 dc, *2 dc in 1 st* twice, 1 dc (24 sts).
Round 4: 5 dc, *2 dc in 1 st* twice, 1 dc, *2 dc in 1 st* twice, 1 dc, *2 dc in 1 st* twice, 7 dc, *2 dc in 1 st* twice, 2 dc (32 sts).
Round 5: 8 dc, *2 dc in 1 st* twice, 4 dc, *2 dc in 1 st* twice, 12 dc, *2 dc in 1 st* twice, 2 dc (38 sts).
Round 6: 10 dc, 2 dc in 1 st, 1 dc, 2 dc in 1 st, 4 dc, 2 dc in 1 st, 1 dc, 2 dc in 1 st, 9 dc, 2 dc in 1 st, 1 dc, *2 dc in 1 st* twice, 2 dc, *2 dc in 1 st* three times (48 sts).
Fasten off with a sl st and cut yarn leaving a 40cm (15¾in) tail.

ARMS (MAKE TWO)

Using Ibiza yarn, make an adjustable ring. The work is done in the round.

Round 1: 8 dc in the loop, join with a sl st in first dc, then close the hole by pulling the yarn tail tight (8 sts).

Rounds 2–15: 1 dc in each st (8 sts).

Fasten off with a sl st and cut yarn leaving a 30cm (11¾in) tail. Do not stuff the arms.

EARS

Right ear

Using Ibiza yarn, make an adjustable ring. This piece is worked in the round.

Round 1: 4 dc in the loop, join with a sl st in first dc, then close the hole by pulling the yarn tail tight (4 sts).

Round 2: 2 dc in each st (8 sts).

Rounds 3–5: 1 dc in each st (8 sts).

Fasten off with a sl st and cut yarn leaving a 30cm (11¾in) tail. Do not stuff the ear.

Left ear

Make in the same way as the right ear, but stop after round 4.

BOW TIE

Fold the edges of the fabric print square into the middle to create a square of around 2.5 x 2.5cm (¾ x ¾in). Pinch the square in the middle to make a bow shape and stitch to hold in place.

MAKING UP

1. Stuff the neck a little.
2. Sew the head to the body. Fix the arms to the sides of the body, around eight rounds beneath the head.
3. Sew the ears on to the head, two rounds beneath the eyes.
4. Attach the muzzle on to the head, two rounds beneath the eyes.
5. Sew the tummy to the body. Sew the bow tie on to the neck.
6. With the embroidery thread, embroider a nose on to the muzzle and a small vertical line below for a mouth. Embroider claws on to the legs and arms and hairs on to the tummy, the neck and on top of the head. Embroider a little beauty spot, a sign of nobility, just below the left eye.
7. On the top of the head, a little further towards the middle than the eyes, create the tufts of hair by securing the thread inside the head (oversewing with tiny invisible stitches several times) then bringing yarn out and trimming it to a length of about 1.5cm (½in). Repeat a further three times on the same side, then four times on the other side to obtain a tuft of four hairs on each side.

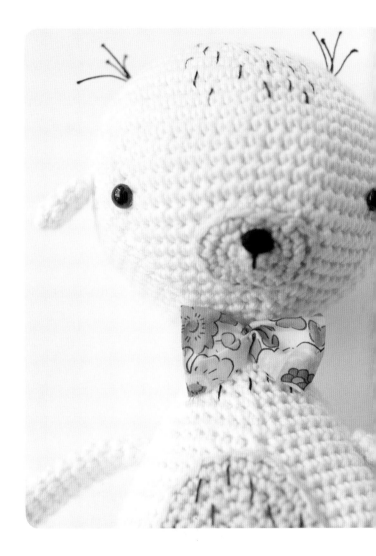

LUCIE THE KOALA

This cute and cuddly little koala bear has decided to leave her tree to discover the world.

MATERIALS

* DMC Natura Just Cotton:
 – Sable: a little over 1 ball (55g)
 – Noir: a few strands
 – Ivory: a few strands
* 2.5mm (UK 12, US C/2) crochet hook
* Stitch marker
* Liberty Mitsi fabric, colour E: 18 x 12cm (7 x 4¾in)
* Erasable pen
* Black embroidery thread: a few strands
* Two black safety eyes, 4mm in diameter
* Fuchsia watercolour pencil
* Sewing equipment
* Toy stuffing

FINISHED SIZE: 16 x 29cm (6¼ x 11½in)

BODY AND HEAD

The body and the head are crocheted as a single piece, working upwards from body to head.

Using Sable yarn, work 22 ch.

Round 1: 1 dc in second ch from hook, then 1 dc in front loop only of next 19 ch, 3 dc in last ch. Work your way along other side of the chain with 1 dc in front loop only of next 20 ch, 3 dc in last ch (46 sts).

Round 2: 21 dc, 3 dc in 1 st, 22 dc, 3 dc in 1 st, 1 dc (50 sts).

Round 3: 22 dc, 3 dc in 1 st, 24 dc, 3 dc in 1 st, 2 dc (54 sts).

Rounds 4–15: 1 dc in each st (54 sts).

Round 16: *2 dc in 1 st, 8 dc* to end (60 sts).

Rounds 17–22: 1 dc in each st (60 sts).

Round 23: *dc2tog, 8 dc* to end (54 sts).

Rounds 24–29: 1 dc in each st (54 sts).

Round 30: *dc2tog, 7 dc* to end (48 sts).

Round 31: *dc2tog, 6 dc* to end (42 sts).

Round 32: *dc2tog, 5 dc* to end (36 sts).

Round 33: *dc2tog, 4 dc* to end (30 sts).

Start the head.

Round 34: *2 dc in 1 st, 4 dc* to end (36 sts).

Stuff the body.

Round 35: *2 dc in 1 st, 5 dc* to end (42 sts).

Round 36: *2 dc in 1 st, 6 dc* to end (48 sts).

Round 37: *2 dc in 1 st, 7 dc* to end (54 sts).

Round 38: *2 dc in 1 st, 8 dc* to end (60 sts).

Rounds 39 and 40: 1 dc in each st (60 sts).

Round 41: *2 dc in 1 st, 9 dc* to end (66 sts).

Round 42: *dc2tog, 9 dc* to end (60 sts).

Rounds 43–47: 1 dc in each st (60 sts).

Round 48: *dc2tog, 8 dc* to end (54 sts).

Round 49: *dc2tog, 7 dc* to end (48 sts).

Round 50: *dc2tog, 6 dc* to end (42 sts).

Round 51: *dc2tog, 5 dc* to end (36 sts).

Round 52: *dc2tog, 4 dc* to end (30 sts).

Attach the safety eyes between rounds 43 and 44, spacing them 8 sts apart.

Round 53: *dc2tog, 3 dc* to end (24 sts).

Stuff the head.

Round 54: *dc2tog, 2 dc* to end (18 sts).

Round 55: *dc2tog, 1 dc* to end (12 sts).

Round 56: *dc2tog* to end (6 sts).

Fasten off with a sl st and cut yarn leaving a 20cm (7¾in) tail.

Close up the small hole with a stitch. Weave in all loose ends.

LEGS (MAKE TWO)

Using Sable yarn, make an adjustable ring. This piece is worked in the round.

Round 1: 6 dc in the loop, join with a sl st in first dc, then close the hole by pulling the yarn tail tight (6 sts).

Round 2: 2 dc in each st (12 sts).

Rounds 3–21: 1 dc in each st (12 sts).

Fasten off with a sl st and cut yarn leaving a 25cm (9¾in) tail.

Stuff the legs.

Remember: dc = sc in the US

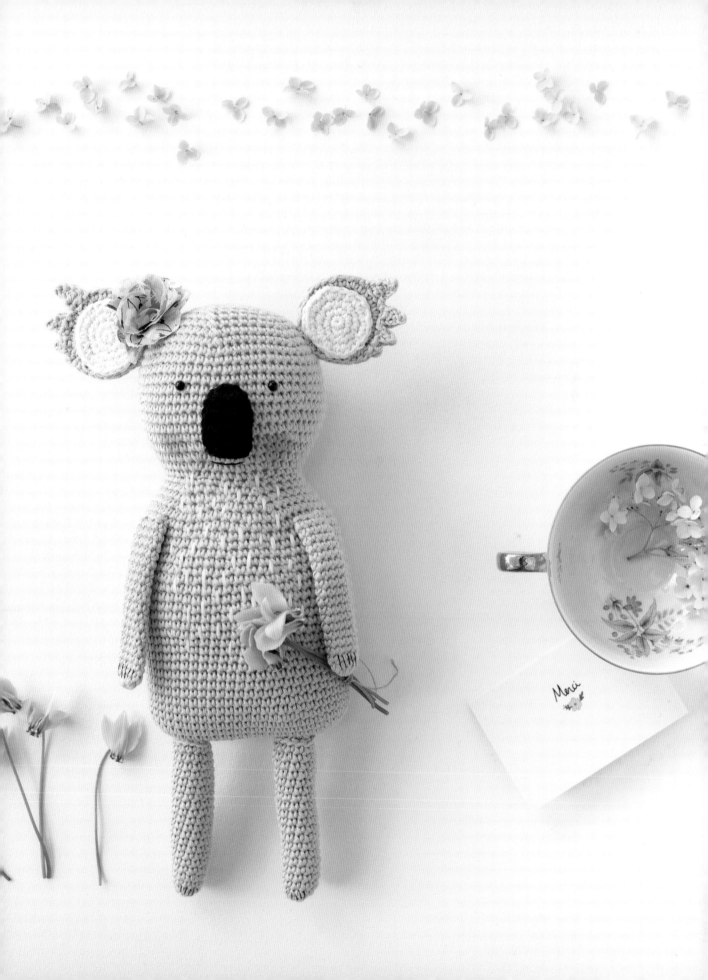

ARMS (MAKE TWO)

Using Sable yarn, make an adjustable ring. This piece is worked in the round.

Round 1: 9 dc in the loop, join with a sl st in first dc, then close the hole by pulling the yarn tail tight (9 sts).

Rounds 2–19: 1 dc in each st (9 sts).

Fasten off with a sl st and cut yarn leaving a 25cm (9¾in) tail. Do not stuff the arms.

NOSE

Using Noir yarn, make an adjustable ring. This piece is worked in the round, starting at the top of the nose.

Round 1: 12 dc in the loop, join with a sl st in first dc, then close the hole by pulling the yarn tail tight (12 sts).

Rounds 2–8: 1 dc in each st (12 sts).

Fasten off with a sl st and cut yarn leaving a 40cm (15¾in) tail. Stuff the nose lightly. Flatten out, then sew the opening closed.

EARS (MAKE TWO)

For the inner ear:

Using Ivory yarn, make an adjustable ring. This piece is worked in the round.

Round 1: 6 dc in the loop, join with a sl st in first dc, then close the hole by pulling the yarn tail tight (6 sts).

Round 2: 2 dc in each st (12 sts).

Round 3: *2 dc in 1 st, 1 dc* to end (18 sts).

Round 4: *2 dc, 2 dc in 1 st* to end (24 sts).

Fasten off with a sl st, and cut yarn leaving a 30cm (11¾in) tail.

For the outer ear:

You will crochet two symmetrical parts that you will then sew together.

First part of outer ear

Using Sable yarn, make an adjustable ring. This piece is worked in the round.

Round 1: 6 dc in the loop, join with a sl st in first dc, then close the hole by pulling the yarn tail tight (6 sts).

Round 2: 2 dc in each st (12 sts).

Round 3: *2 dc in 1 st, 1 dc* to end (18 sts).

Round 4: *2 dc, 2 dc in 1 st* to end (24 sts).

Round 5: this round will be different as you are going to form the pointed ends of the ear. You need to work 1 chain stitch in which you will work different stitches forming a point that will then be worked into the st of the previous round. This technique is similar to that used for Fleur's crown (see page 22). It is fairly simple, as you will see!

First point: work 1 sl st in next st of previous round, 2 ch, 1 sl st in same st of previous round (or simply work 2 sl sts separated by 2 ch in same st of previous round).

Second point: in next st, work 1 sl st, 3 ch, then work along this chain as follows: 1 sl st in second ch from hook, 1 dc in last ch. You have arrived at the end of the chain. Work 1 sl st in the same st of previous round that you used to make the chain.

Third point: in next st, work 1 sl st, 4 ch, then work along this chain as follows: 1 sl st in second ch from hook, 1 dc in next ch, 1 htr in last ch. You have arrived at the end of the chain. Work 1 sl st in the next st of previous round after the one you used to make the chain.

Fourth point: in next st, work 1 sl st, 5 ch, then work along this chain as follows: 1 sl st in second ch from hook, 1 dc in next ch, 1 htr in next ch, 1 tr in last ch. You have arrived at the end of the chain. Work 1 sl st in next st of previous round.
Cut yarn, leaving a 40cm (15¾in) tail.

Second part of the outer ear

Using Sable yarn, make an adjustable ring. This piece is worked in the round.
Round 1: 6 dc in the loop, join with a sl st in first dc, then close the hole by pulling the yarn tail tight (6 sts).
Round 2: 2 dc in each st (12 sts).
Round 3: *2 dc in 1 st, 1 dc* to end (18 sts).
Round 4: *2 dc, 2 dc in 1 st* to end (24 sts).
Round 5: this round is identical to round 5 of the first part of the outer ear, except you will start with the fourth point – the biggest one – and then do the third, second and first.

Fourth point: in next st, work 1 sl st, 5 ch, then work along this chain as follows: a sl st in second ch from hook, 1 dc in next ch, 1 htr in next ch, 1 tr in last ch. You have arrived at the end of the chain. Work 1 sl st in next st of previous round.

Third point: in next st, work 1 sl st, 4 ch, then work along this chain as follows: a sl st in second ch from hook, 1 dc in next ch, 1 htr in last ch. You have arrived at the end of the chain. Work 1 sl st in the next st.

Second point: in the next st, work 1 sl st, 3 ch, then work along this chain as follows: a sl st in second ch from hook, 1 dc in last ch. You have arrived at the end of the chain. Work 1 sl st in the same st of the previous round that you used to make the chain.

First point: work 1 sl st in next st of previous round, 2 ch, 1 sl st in same st of previous round.
Cut yarn, leaving a 10cm (4in) tail.

Remember: in the US, tr = dc and htr = hdc

FABRIC FLOWER

1. On a scrap of fabric, trace the flower template (page 63) six times. Cut out the flowers. Lay them on top of each other, right side up and staggering the direction of the petals.
2. Secure with a few stitches in the centre.
3. Pinch the centre to create a pretty open flower and stitch into place.

MAKING UP

1. Sew the two outer ear parts together, wrong sides together. Sew the inner ear onto the outer ear. Repeat for the second ear.
2. Sew the ears on to the head. Fix the arms to the sides of the body, five or six rounds below the head.
3. Sew the legs onto the body. Sew the nose onto the head, placing it between the eyes.
4. Using the black embroidery thread, embroider the mouth below the nose. Embroider the claws. Using Ivory yarn, embroider hairs on the tummy.
5. Paint the cheeks on to Lucie's face (see page 9).

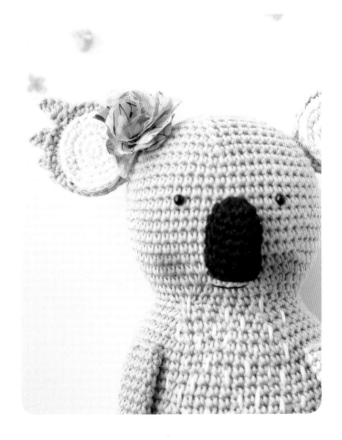

MARTIN THE RABBIT

Martin is perfectly house-trained and little ones can carry him
around by his long legs, arms or ears.

······ MATERIALS ······

* DMC Natura Just Cotton:
 – Nacar: 2 balls (100g)
 – Noir: a few strands
 – Lobelia: a few strands
* 2.5mm (UK 12, US C/2) crochet hook

* Stitch marker
* Liberty Capel fabric, grey: 19 x 44cm
 (7½ x 17¼in)
* Erasable pen
* Black embroidery thread: a few strands

* Pink watercolour pencil
* Sewing equipment
* Toy stuffing

FINISHED SIZE: 13 x 42cm (5 x 16½in)

HEAD

Using Nacar yarn, make an adjustable ring (see page 6). This
piece is worked in the round.

Round 1: 9 dc in the loop, join with a sl st in first dc, then close
the hole by pulling the yarn tail tight (9 sts).
Round 2: *2 dc in 1 st, 2 dc* to end (12 sts).
Round 3: *2 dc in 1 st, 2 dc* to end (16 sts).
Round 4: *2 dc in 1 st, 3 dc* to end (20 sts).
Round 5: *2 dc in 1 st, 4 dc* to end (24 sts).
Round 6: *2 dc in 1 st, 2 dc* four times, then 12 dc (28 sts).
Round 7: *2 dc in 1 st, 3 dc* four times, 12 dc (32 sts).
Round 8: *2 dc in 1 st, 4 dc* four times, 12 dc (36 sts).
Round 9: *2 dc in 1 st, 5 dc* four times, 12 dc (40 sts).
Round 10: *2 dc in 1 st, 6 dc* four times, 12 dc (44 sts).
Round 11: *2 dc in 1 st, 7 dc* four times, 12 dc (48 sts).
Round 12: 1 dc in each st (48 sts).
Round 13: *2 dc in 1 st, 8 dc* four times, 12 dc (52 sts).
Rounds 14 and 15: 1 dc in each st (52 sts).
Round 16: *2 dc in 1 st, 9 dc* four times, then 12 dc (56 sts).
Rounds 17–25: 1 dc in each st (56 sts).
Round 26: *dc2tog, 12 dc* to end (52 sts).
Rounds 27 and 28: 1 dc in each st (52 sts).
Round 29: *dc2tog, 11 dc* to end (48 sts).
Round 30: 1 dc in each st (48 sts).
Round 31: *dc2tog, 6 dc* to end (42 sts).
Round 32: *dc2tog, 5 dc* to end (36 sts).
Round 33: *dc2tog, 4 dc* to end (30 sts).
Round 34: *dc2tog, 3 dc* to end (24 sts).
Stuff the head.
Round 35: *dc2tog, 2 dc* to end (18 sts).
Round 36: *dc2tog, 1 dc* to end (12 sts).
Round 37: *dc2tog* to end (6 sts).
Fasten off with a sl st and cut yarn leaving a 20cm (7¾in) tail.
Close up the small hole with a stitch. Weave in yarn end.

BODY

Using Nacar yarn, make an adjustable ring. This piece is worked
in the round.

Round 1: 6 dc in the loop, join with a sl st in first dc, then close
the hole by pulling the yarn tail tight (6 sts).
Round 2: 2 dc in each st (12 sts).
Round 3: *2 dc in 1 st, 1 dc* to end (18 sts).
Round 4: *2 dc in 1 st, 2 dc* to end (24 sts).
Round 5: *2 dc in 1 st, 3 dc* to end (30 sts).
Round 6: *2 dc in 1 st, 4 dc* to end (36 sts).
Round 7: *2 dc in 1 st, 5 dc* to end (42 sts).
Round 8: *2 dc in 1 st, 6 dc* to end (48 sts).
Round 9: *2 dc in 1 st, 7 dc* to end (54 sts).
Round 10: *2 dc in 1 st, 8 dc* to end (60 sts).
Round 11: *2 dc in 1 st, 9 dc* to end (66 sts).
Rounds 12–15: 1 dc in each st (66 sts).
Round 16: *2 dc in 1 st, 10 dc* to end (72 sts).
Rounds 17 and 18: 1 dc in each st (72 sts).
Round 19: *2 dc in 1 st, 11 dc* to end (78 sts).
Rounds 20–26: 1 dc in each st (78 sts).
Round 27: *dc2tog, 8 dc* seven times, dc2tog, 6 dc (70 sts).
Rounds 28–32: 1 dc in each st (70 sts).
Round 33: *dc2tog, 5 dc* to end (60 sts).
Rounds 34–36: 1 dc in each st (60 sts).
Round 37: *dc2tog, 8 dc* to end (54 sts).
Rounds 38 and 39: 1 dc in each st (54 sts).
Round 40: *dc2tog, 7 dc* to end (48 sts).
Rounds 41 and 42: 1 dc in each st (48 sts).
Round 43: *dc2tog, 6 dc* to end (42 sts).
Rounds 44 and 45: 1 dc in each st (42 sts).
Round 46: *dc2tog, 5 dc* to end (36 sts).
Rounds 47 and 48: 1 dc in each st (36 sts).

Remember: dc = sc in the US

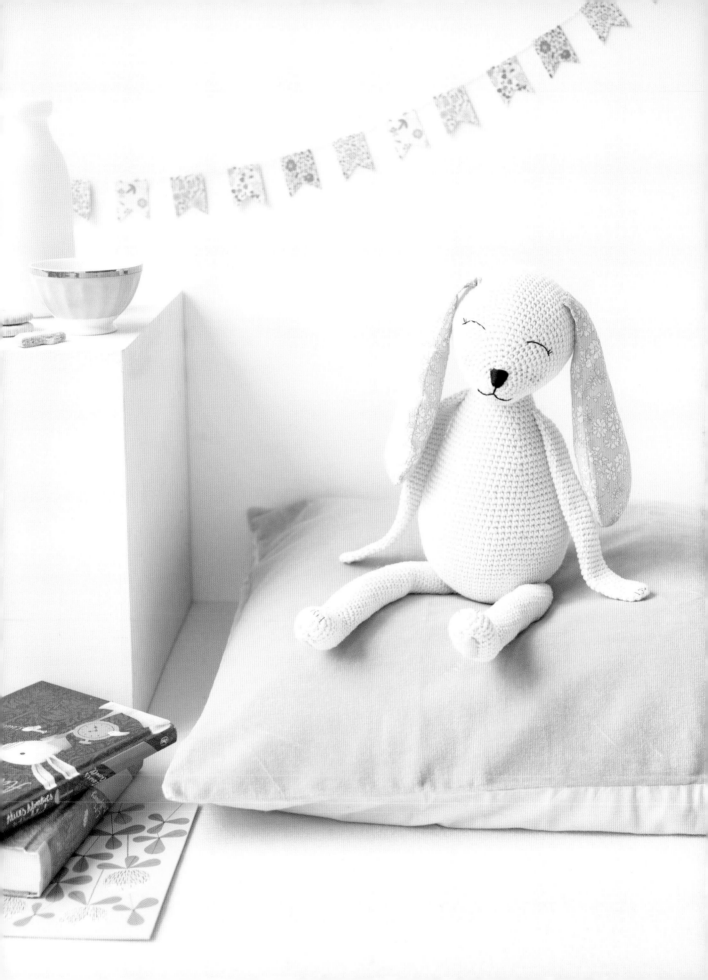

Round 49: *dc2tog, 4 dc* to end (30 sts).
Rounds 50 and 51: 1 dc in each st (30 sts).
Round 52: *dc2tog, 3 dc* to end (24 sts).
Round 53: 1 dc in each st (24 sts).
Stuff the body.
Fasten off with a sl st and cut yarn leaving a 40cm (15¾in) tail.

LEGS (MAKE TWO)

Using Nacar yarn, make an adjustable ring. This piece is worked in the round.
Round 1: 6 dc in the loop, join with a sl st in first dc, then close the hole by pulling the yarn tail tight (6 sts).
Round 2: 2 dc in each st (12 sts).
Round 3: *2 dc in 1 st, 1 dc* to end (18 sts).
Round 4: *2 dc in 1 st, 8 dc* to end (20 sts).
Rounds 5–11: 1 dc in each st (20 sts).
Round 12: 2 dc, *dc2tog* twice, 7 dc, 2 dc in 1 st, 2 dc in 1 st, 5 dc (20 sts).
Round 13: 1 dc, *dc2tog* twice, 7 dc, 2 dc in 1 st, 2 dc, 2 dc in 1 st, 6 dc (20 sts).
Round 14: *dc2tog* twice, 16 dc (18 sts).
Stuff the foot a little.
Rounds 15–49: 1 dc in each st (18 sts).
Fasten off with a sl st and cut yarn leaving a 30cm (11¾in) tail.
Stuff the legs very lightly.

ARMS (MAKE TWO)

Using Nacar yarn, make an adjustable ring. This piece is worked in the round.
Round 1: 6 dc in the loop, join with a sl st in first dc, then close the hole by pulling the yarn tail tight (6 sts).
Round 2: 2 dc in each st (12 sts).
Rounds 3–42: 1 dc in each st (12 sts).
Fasten off with a sl st and cut yarn leaving a 30cm (11¾in) tail.
Do not stuff the arms.

FABRIC EARS (MAKE TWO)

1. Cut the fabric into two pieces measuring 16 x 19cm (6¼ x 7½in) (for the ears) and 1 piece measuring 12 x 19cm (4¾ x 7½in) (for the tail).
2. Fold the fabric for the ear right sides together to form an 8 x 19cm (3¼ x 7½in) rectangle. Trace the template for the ear (see page 63), adding a 0.5cm (¼in) seam allowance, and cut out.
3. Sew on a sewing machine or by hand, leaving a 2cm (¾in) opening.
4. Turn the ear the right side out and stuff lightly as the ears should be very soft.
5. Sew up the opening by hand.

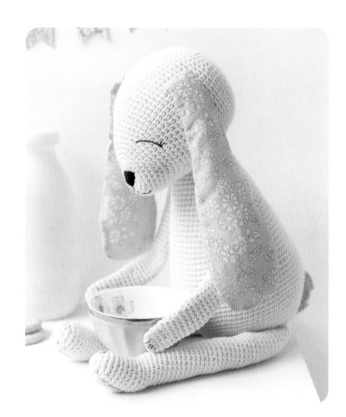

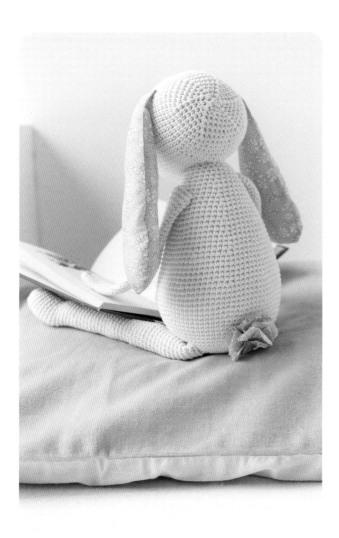

MAKING UP

1. Sew the head to the body. Sew the eyes onto the head, placing them quite high up.

2. Attach the arms to the shoulders, four rounds below the head. Sew the legs to the body.

3. Using Noir yarn, embroider the nose, muzzle and eyes. Using the black embroidery thread, embroider the claws on the legs and arms.

4. Using Lobelia yarn, embroider the little pads on the paws and five little dots above to look like paw prints.

5. Paint the cheeks onto Martin's face (see page 9).

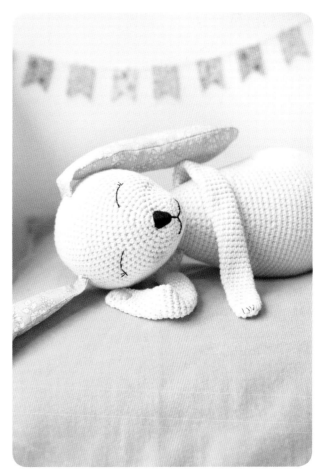

FABRIC TAIL

1. Trace the template for the tail on to the 12 x 19cm (4¾ x 7½in) fabric (see page 63) six times and cut out the circles without any seam allowance.

2. Fold the first circle in half, wrong sides together. Fold in half again. You should now have a quarter circle.

3. Secure with a few stitches on the pointed corner. Repeat for the other circles.

4. Sew the six quarter-circles together at the pointed corners, then open them out and fluff up slightly to resemble a flower.

MIMI THE MOUSE

She's a fashionable little mouse with her Liberty print bow and belt.

MATERIALS

* DMC Natura Just Cotton:
 – Salomé: 35g
 – Amaranto: 20g
 – Noir: a few strands
* 2.5mm (UK 12, US C/2) crochet hook
* Stitch marker
* Liberty Betsy Ann fabric, Sweet Pink: 4 x 7cm (1½ x 2¾in)
* Liberty Betsy Ann cord, Sweet Pink: 30cm (11¾in)
* Black embroidery thread: a few strands
* Erasable pen
* Two black safety eyes, 6mm in diameter
* Pink watercolour pencil
* Sewing equipment

FINISHED SIZE: 12 x 33cm (4¾ x 13in)

HEAD

Using Salomé yarn, make an adjustable ring (see page 6). This piece is worked in the round.

Round 1: 6 dc in the loop, join with a sl st in first dc, then close the hole by pulling the yarn tail tight (6 sts).
Round 2: 1 dc in each st (6 sts).
Round 3: *2 dc in 1 st, 1 dc* to end (9 sts).
Round 4: *2 dc in 1 st, 2 dc* to end (12 sts).
Round 5: *2 dc in 1 st, 1 dc* to end (18 sts).
Round 6: *2 dc in 1 st, 2 dc* to end (24 sts).
Round 7: *2 dc in 1 st, 3 dc* to end (30 sts).
Round 8: *2 dc in 1 st, 4 dc* to end (36 sts).
Round 9: *2 dc in 1 st, 5 dc* to end (42 sts).
Round 10: *2 dc in 1 st, 6 dc* to end (48 sts).
Round 11: *2 dc in 1 st, 7 dc* to end (54 sts).
Round 12: *2 dc in 1 st, 8 dc* to end (60 sts).
Rounds 13–22: 1 dc in each st (60 sts).
Round 23: *dc2tog, 8 dc* to end (54 sts).
Round 24: *dc2tog, 7 dc* to end (48 sts).
Round 25: *dc2tog, 6 dc* to end (42 sts).
Round 26: *dc2tog, 5 dc* to end (36 sts).
Round 27: *dc2tog, 4 dc* to end (30 sts).
Round 28: *dc2tog, 3 dc* to end (24 sts).
Attach safeety eyes between rounds 13 and 14. Stuff the head.
Round 29: *dc2tog, 2 dc* to end (18 sts).
Round 30: *dc2tog, 1 dc* to end (12 sts).
Round 31: *dc2tog* to end (6 sts).
Fasten off with a sl st and cut yarn leaving a 20cm (7¾in) tail.
Close up the small hole with a stitch.

LEGS (MAKE TWO)

Using Salomé yarn, make an adjustable ring. This piece is worked in the round.

Round 1: 6 dc in the loop, join with a sl st in first dc, then close the hole by pulling the yarn tail tight (6 sts).
Round 2: 2 dc in each st (12 sts).
Round 3: *2 dc in 1 st, 1 dc* to end (18 sts).
Round 4: 1 dc in back loop only of each st (18 sts).
Rounds 5 and 6: 1 dc in each st (18 sts).
Round 7: *dc2tog, 4 dc* to end (15 sts).
Rounds 8–29: 1 dc in each st (15 sts).
Continue with Amaranto yarn.
Rounds 30–38: 1 dc in each st (15 sts).
Fasten off with a sl st and cut yarn leaving a 10cm (4in) tail.
Make a second identical leg but do not cut yarn.
Round 39: work 2 ch. Take the first leg. Point the foot downwards. Join the first leg to the chain with 1 dc, then 2 dc in 1 st, 2 dc, 2 dc in 1 st, 6 dc, 2 dc in 1 st, 3 dc. You have worked all round the first leg and are back at the chain. 1 dc in front loop only of each ch. You have arrived at the second leg. Continue around the second leg working 2 dc in 1 st, 3 dc, 2 dc in 1 st, 6 dc, 2dc in 1 st, 3 dc. You are back at the chain. 1 dc in front loop only of each ch. You now have 40 dc.
Mark the start of the new round.

Remember: dc = sc in the US

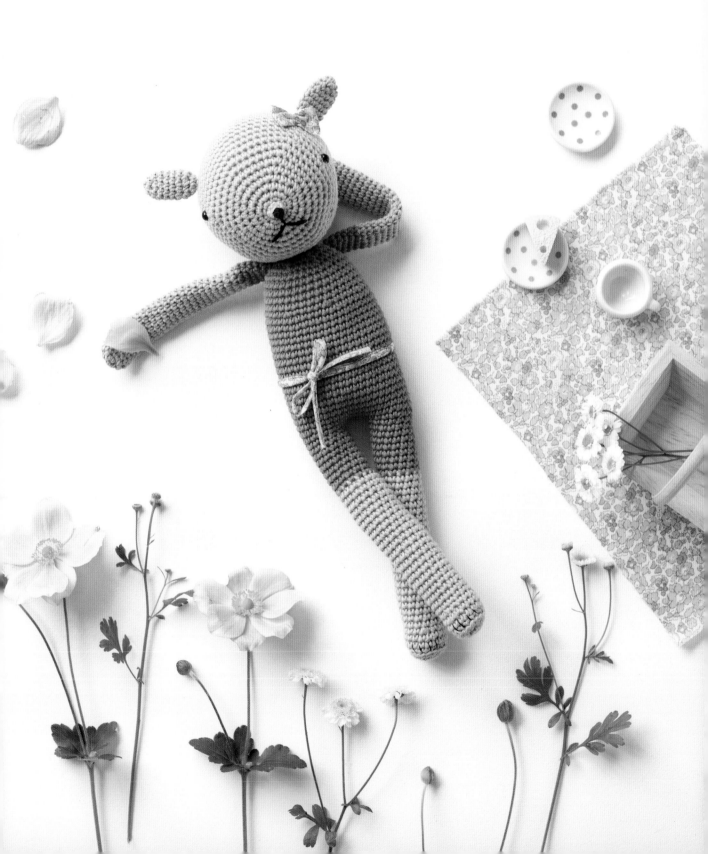

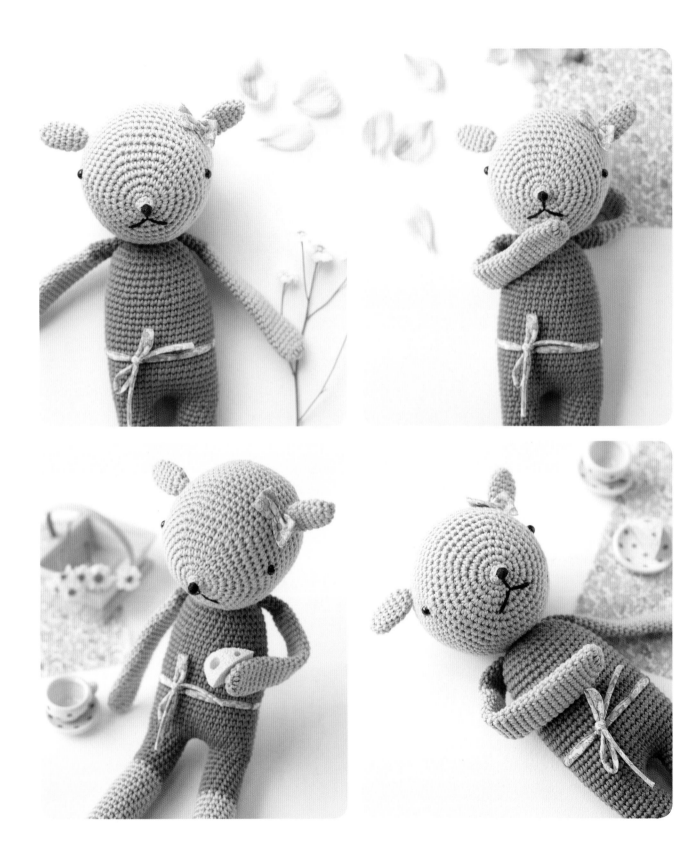

BODY

Round 40: *19 dc, 2 dc in 1 st* twice, 4 dc (42 sts).
Stuff the legs.
Rounds 41–54: 1 dc in each st (42 sts).
Round 55: *dc2tog, 4 dc* to end (35 sts).
Rounds 56–60: 1 dc in each st (35 sts).
Round 61: *dc2tog, 3 dc* to end (28 sts).
Round 62: *dc2tog, 2 dc* to end (21 sts).
Round 63: *dc2tog, 1 dc* to end (14 sts).
Stuff the body.
Fasten off with a sl st and cut yarn leaving a 40cm (15¾in) tail.

ARMS (MAKE TWO)

Using Salomé yarn, make an adjustable ring. This piece is worked in the round.
Round 1: 6 dc in the loop, join with a sl st in first dc, then close the hole by pulling the yarn tail tight (6 sts).
Round 2: 2 dc in each st (12 sts).
Round 3: 2 dc in 1 st, 11 dc (13 sts).
Rounds 4–7: 1 dc in each st (13 sts).
Round 8: dc2tog, 11 dc (12 sts).
Rounds 9–24: 1 dc in each st (12 sts).
Continue with Amaranto yarn.
Round 25: dc2tog, 10 dc (11 sts).
Rounds 26–30: 1 dc in each st (11 sts).
Fasten off with a sl st and cut yarn, leaving a 30cm (11¾in) tail.
Do not stuff the arms.

EARS (MAKE TWO)

Using Salomé yarn, make an adjustable ring. This piece is worked in the round.
Round 1: 4 dc in the loop, join with a sl st in first dc, then close the hole by pulling the yarn tail tight (4 sts).
Round 2: 2 dc in each st (8 sts).
Round 3: *2dc in 1 st, 3 dc* to end (10 sts).
Rounds 4–7: 1 dc in each st (10 sts).
Round 8: *dc2tog, 1 dc* twice, dc2tog, 2 dc (7 sts).
Round 9: dc2tog, 1 dc, dc2tog, 2 dc (5 sts).
Fasten off with a sl st and cut yarn leaving a 25cm (9¾in) tail.
Do not stuff the ears.

FACE

Using Noir yarn, embroider the nose and muzzle.
Paint the cheeks onto Mimi's face (see page 9).

> **Tip**
>
> *Do not worry about setting the eyes a long way apart: this is precisely what gives Mimi her charm.*

FABRIC BOW

Fold the fabric rectangle so you hide the raw edges, to get a smaller rectangle of around 4 x 3cm (1½ x 1¼in). Pinch in the middle to make a bow, and hold in place with a few stitches.

MAKING UP

1. Sew on the bow at the base of the ear, at a slight angle.
2. Sew the head to the body. Attach the arms to the shoulders, a little to the back of the body.
3. Using the embroidery thread, embroider the claws on the legs and arms and a beauty spot beneath the left cheek.
4. Thread the Liberty cord like a belt, slipping it through a loop of 1 dc every third stitch, and tie in a bow to finish.

> **Tip**
>
> *Mice like cheese and Mimi is no exception! Take a thick yellow sponge and cut off a triangle. If the sponge already has holes in it, so much the better. If not, cut some holes with a pair of small, pointed scissors.*

BERTIE THE FURRY BEAR

Little ones will love to snuggle up and share their dreams with this furry bear with the flowery tummy.

··· MATERIALS ···

- ✳ DMC Natura Just Cotton:
 – Agatha: 40g
 – Orquidea: a few strands
 – Ivory: a few strands
 – Noir: a few strands
- ✳ 2.5mm (UK 12, US C/2) crochet hook
- ✳ Stitch marker
- ✳ Liberty Mitsi fabric, Plum: 9 x 14cm (3½ x 5½in)
- ✳ Erasable pen
- ✳ Sewing equipment
- ✳ Toy stuffing

FINISHED SIZE: 12 x 20cm (4¾ x 7¾in)

LEGS (MAKE TWO)

Using Agatha yarn, make an adjustable ring (see page 6). This piece is worked in the round.

Round 1: 9 dc in the loop, join with a sl st in first dc, then close the hole by pulling the yarn tail tight (9 sts).

Rounds 2–5: 1 dc in each st (9 sts).

Fasten off with a sl st and cut yarn leaving a 10cm (4in) tail. Make a second identical leg but do not cut yarn.

Round 6: work 20 ch. Take the first leg. Point the foot downwards. Join the first leg to the chain with 1 dc, then 1 dc in the same st. 7 dc round first leg, then 2 dc in last st of leg. You have worked all round the first leg and should now have 11 dc. Work 20 dc along front loop only of chain. You have arrived at the second leg. Continue around second leg working 2 dc in 1 st, 7 dc, 2dc in 1 st. You have now worked all round the second leg and back to the chain. Work 20 dc in front loop only of chain. You should have 62 dc (11 dc around first leg + 20 dc along chain + 11 dc around second leg + 20 dc back along chain). Work another 21 dc.

Mark the start of the new round.

BODY

Rounds 7–43: 1 dc in each st (62 sts).

Round 44: *dc2tog, 9 dc, dc2tog, 18 dc* to end (58 sts).

Rounds 45–48: 1 dc in each st (58 sts).

Round 49: *dc2tog, 9 dc, dc2tog, 16 dc* to end (54 sts).

Rounds 50–52: 1 dc in each st (54 sts).

Round 53: 1 dc, dc2tog, 7 dc, dc2tog, 15 dc, dc2tog, 6 dc, dc2tog, 17 dc (50 sts).

Round 54: 1 dc in each st (50 sts).

Stuff the legs firmly. Stuff the body.

Round 55: *dc2tog* to end (25 sts).

Round 56: *dc2tog* twelve times, 1 dc (13 sts).

Round 57: 1 dc, *dc2tog* to end. (7 sts).

Fasten off with a sl st and cut yarn leaving a 25cm (9¾in) tail. Close up the small hole with a stitch. Work in end of yarn.

ARMS (MAKE TWO)

Using Agatha yarn, make an adjustable ring. This piece is worked in the round.

Round 1: 6 dc in the loop, join with a sl st in first dc, then close the hole by pulling the yarn tail tight (6 sts).

Rounds 2–7: 1 dc in each st (6 sts).

Fasten off with a sl st and cut yarn leaving a 30cm (11¾in) tail. Stuff the arms lightly.

Remember: dc = sc in the US

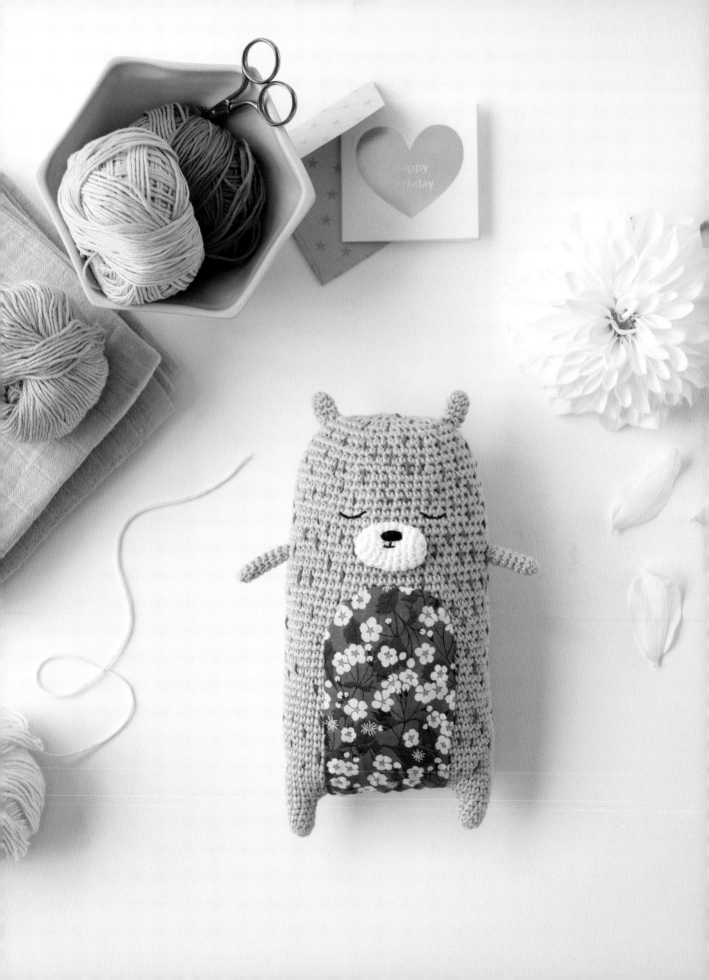

EARS (MAKE TWO)

Using Agatha yarn, make an adjustable ring. This piece is worked in the round.

Round 1: 7 dc in the loop, join with a sl st in first dc, then close the hole by pulling the yarn tail tight (7 sts).

Rounds 2–4: 1 dc in each st (7 sts).

Fasten off with a sl st and cut yarn leaving a 30cm (11¾in) tail. Stuff the ears lightly.

MUZZLE

Using Ivory yarn, make an adjustable ring. This piece is worked in the round.

Round 1: 7 dc in the loop, join with a sl st in first dc, then close the hole by pulling the yarn tail tight (7 sts).

Round 2: 2 dc in each st (14 sts).

Rounds 3–9: 1 dc in each st (14 sts).

Round 10: *dc2tog* to end (7 sts).

Fasten off with a sl st and cut yarn leaving a 40cm (15¾in) tail.

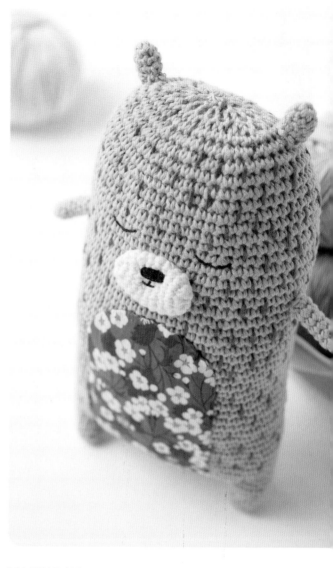

MAKING UP

1. Sew the arms to the body at rounds 34 and 35.

2. Stuff the ears and sew them to the head.

3. Flatten the muzzle and sew on between rows 34 to 39.

FACE

Using Noir yarn, embroider the nose onto the muzzle. Embroider the eyes at round 40. The eyes should be just over 1cm (½in) wide.

FABRIC TUMMY

1. Trace the template of the tummy (see page 64) on to the reverse side of the fabric and cut out, adding a 0.7cm (⅜in) seam allowance.
2. Clip the fabric (with the points of the scissors, cut small v-shaped notches around the edge of the fabric). Note: do not cut up to the seam line, always leave an allowance of more than 1mm for the seam!
3. Place the fabric right side down and tack the seam allowance, wrong sides together. Pin the tummy to the bear and sew it on by hand using slip stitch.

FUR

Using the Orquidea thread, embroider vertical hairs onto the front and back of the bear's body, with a little less around the face. Make sure you don't pull the yarn too tight when you are embroidering the fur; otherwise, the body will pucker.

Tip

For a pretty little girl bear, embroider eyelashes and apply some rosy cheeks using a pink or red watercolour pencil.

EDWARD THE REINDEER

Well dressed and serious, but not too much so, Edward is quite
the gentleman with his Liberty print tie.

MATERIALS

- DMC Natura Just Cotton:
 - Ivory: 1 ball (45g)
 - Black: a few strands
- DMC Lumina Gold: a few strands
- 2.5mm (UK 12, US C/2) crochet hook
- Stitch marker
- Liberty Pepper bias binding, colour B: 17cm (6¾in)
- Black embroidery thread: a few strands
- Toy stuffing
- Two bronze safety eyes, 6mm in diameter
- Red watercolour pencil
- Sewing equipment

FINISHED SIZE: 10 x 36cm (4 x 14¼in)

HEAD

Using Ivory yarn, make an adjustable ring (see page 6). This piece
is worked in the round.

Round 1: 6 dc in the loop, join with a sl st in first dc, then close
the hole by pulling the yarn tail tight (6 sts).

Round 2: *2 dc in 1 st* to end (12 sts).

Round 3: *2 dc in 1 st, 3 dc* to end (15 sts).

Round 4: 1 dc in each st (15 sts).

Round 5: *2 dc in 1 st, 4 dc* to end (18 sts).

Rounds 6 and 7: 1 dc in each st (18 sts).

Round 8: *2 dc in 1 st, 5 dc* to end (21 sts).

Round 9: *2 dc in 1 st, 6 dc* to end (24 sts).

Round 10: *2 dc in 1 st, 3 dc* to end (30 sts).

Rounds 11 and 12: 1 dc in each st (30 sts).

Round 13: *2 dc in 1 st, 4 dc* to end (36 sts).

Round 14: 1 dc in each st (36 sts).

Round 15: *2 dc in 1 st, 5 dc* to end (42 sts).

Round 16: *2 dc in 1 st, 6 dc* to end (48 sts).

Rounds 17–22: 1 dc in each st (48 sts).

Round 23: *dc2tog, 6 dc* to end (42 sts).

Round 24: 1 dc in each st (42 sts).

Round 25: *dc2tog, 5 dc* to end (36 sts).

Round 26: 1 dc in each st (36 sts).

Round 27: *dc2tog, 4 dc* to end (30 sts).

Round 28: *dc2tog, 3 dc* to end (24 sts). Attach the eyes
between rounds 16 and 17, spacing them 12 dc apart.
Stuff the head.

Round 29: *dc2tog, 2 dc* to end (18 sts).

Round 30: *dc2tog, 1 dc* to end (12 sts).

Round 31: *dc2tog* to end (6 sts).
Fasten off with a sl st and cut yarn leaving a 20cm (7¾in) tail.
Close up the small hole with a stitch.

BODY

Using Ivory yarn, make an adjustable ring. This piece is worked in
the round.

Round 1: 6 dc in the loop, join with a sl st in first dc, then close
the hole by pulling the yarn tail tight (6 sts).

Round 2: 2 dc in each st (12 sts).

Round 3: *2 dc in 1 st, 1 dc* to end (18 sts).

Round 4: *2 dc in 1 st, 2 dc* to end (24 sts).

Round 5: *2 dc in 1 st, 3 dc* to end (30 sts).

Round 6: *2 dc in 1 st, 4 dc* to end (36 sts).

Round 7: *2 dc in 1 st, 5 dc* to end (42 sts).

Round 8: *2 dc in 1 st, 6 dc* to end (48 sts).

Rounds 9–20: 1 dc in each st (48 sts).

Round 21: *dc2tog, 6 dc* to end (42 sts).

Rounds 22–24: 1 dc in each st (42 sts).

Round 25: *dc2tog, 5 dc* to end (36 sts).

Round 26: 1 dc in each st (36 sts).

Round 27: *dc2tog, 4 dc* to end (30 sts).

Round 28: *dc2tog, 3 dc* to end (24 sts).

Round 29: 1 dc in each st (24 sts).
Stuff the body.

Round 30: *dc2tog, 4 dc* to end (20 sts).

Rounds 31–33: 1 dc in each st (20 sts).
Fasten off with a sl st and cut yarn leaving a 40cm (15¾in) tail.
Close up the small hole with a stitch.

Remember: dc = sc in the US

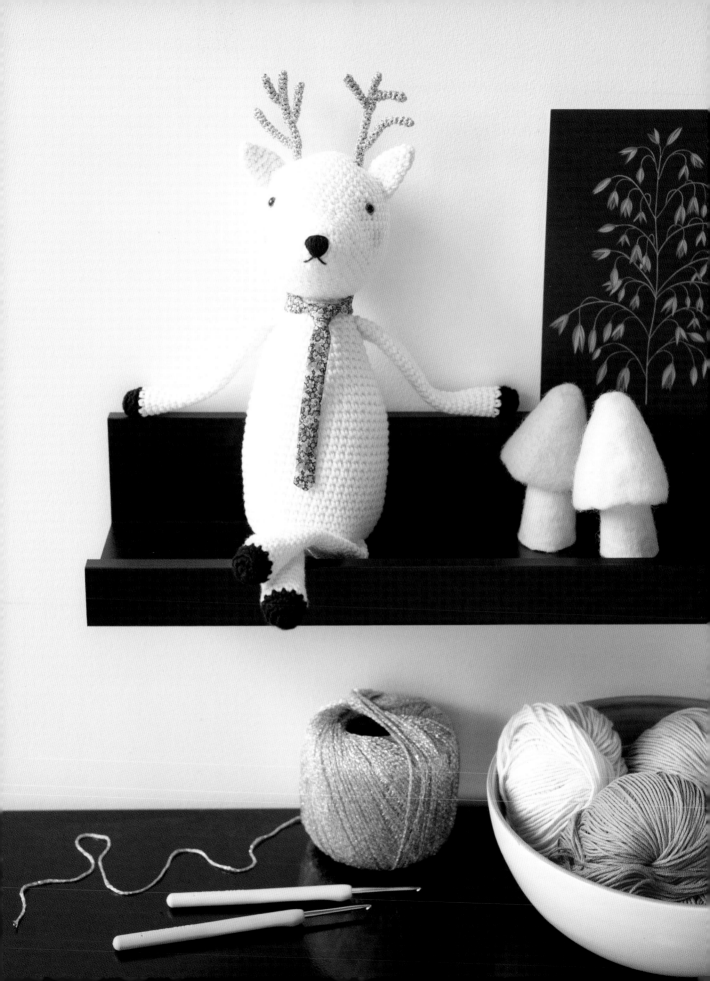

LEGS (MAKE TWO)

Using Noir yarn, make an adjustable ring. This piece is worked in the round.

Round 1: 6 dc in the loop, join with a sl st in first dc, then close the hole by pulling the yarn tail tight (6 sts).

Round 2: 2 dc in each st (12 sts).

Round 3: 1 dc in the back loop only of each st (12 sts).

Round 4: 1 dc in each st (12 sts).

Continue with Ivory yarn.

Rounds 5–10: 1 dc in each st (12 sts).

Stuff the hoof a little.

Rounds 11–30: 1 dc in each st (12 sts).

Fasten off with a sl st and cut yarn, leaving a 30cm (11¾in) tail. Do not stuff the legs.

ARMS (MAKE TWO)

Using Noir yarn, make an adjustable ring. This piece is worked in the round.

Round 1: 5 dc in the loop, join with a sl st in first dc, then close the hole by pulling the yarn tail tight (5 sts).

Round 2: 2 dc in each st (10 sts).

Round 3: 1 dc in back loop only of each st (10 sts).

Round 4: 1 dc in each st (10 sts).

Continue with Ivory yarn.

Rounds 5–10: 1 dc in each st (10 sts).

Stuff the hoof a little.

Rounds 11–30: 1 dc in each st (10 sts).

Fasten off with a sl st and cut yarn, leaving a 30cm (11¾in) tail. Do not stuff the arms.

EARS (MAKE TWO)

Using Ivory yarn, make an adjustable ring. This piece is worked in the round.

Round 1: 4 dc in the loop, join with a sl st in first dc, then close the hole by pulling the yarn tail tight (4 sts).

Round 2: *2 dc in 1 st, 1 dc* to end (6 sts).

Round 3: 2 dc in 1 st, 5 dc (7 sts).

Round 4: 2 dc in 1 st, 6 dc (8 sts).

Round 5: 2 dc in 1 st, 7 dc (9 sts).

Round 6: 2 dc in 1 st, 8 dc (10 sts).

Round 7: 2 dc in 1 st, 9 dc (11 sts).

Fasten off with a sl st and cut yarn leaving a 25cm (9¾in) tail. Do not stuff the ears.

Tip

Edward will also look very elegant if you embroider some golden fur over his body.

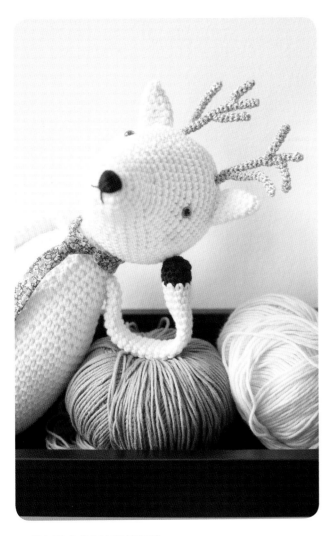

MAKING UP

1. Make up the antlers by sewing the second, third and fourth tubes to the first; the shortest tube should be at the top.
2. Sew the head to the body. Sew the ears onto the head. Sew the antlers on to the head. Attach the arms to the shoulders, a little to the back of the body.
3. Using black embroidery thread, embroider the nose and muzzle.
4. Paint the cheeks onto Edward's face (see page 9).

FABRIC TIE

Make a tie out of Liberty bias binding. Fold the corners of the end of the tie behind to form a point and stitch to secure in place.

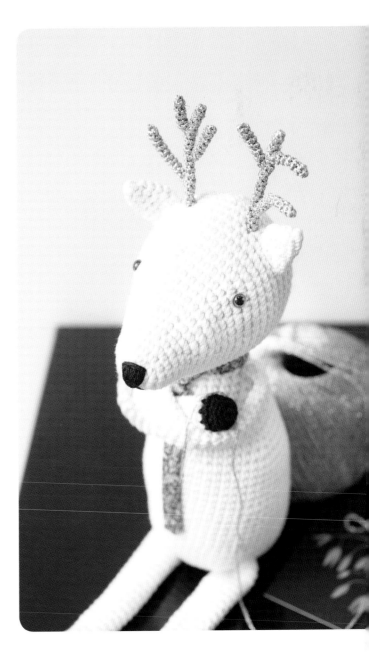

ANTLERS (MAKE TWO)

Following the instructions below, make four small tubes: the first 5.5cm (2¼in), the second 4cm (1½in), the third 2cm (¾in) and the fourth 1.5cm (½in).

Using Gold yarn, make an adjustable ring. This piece is worked in the round.

Round 1: 4 dc in the loop, join with a sl st in first dc, then close the hole by pulling the yarn tail tight (4 sts).

Round 2: 1 dc in each st (4 sts).

Continue in this way until it is the right length.

Fasten off with a sl st and cut yarn leaving a 15cm (6in) tail.

Stuff each tube a little.

TEMPLATES

OLA THE BEE (p. 14)
Wing no. 1

OLA THE BEE (p. 14)
Wing no. 2

VANIA THE TOMCAT (p. 24)
Shorts

Tummy hem

← Central seam line front/back

Outer edge of shorts (place on fold) →

Crotch

← Internal edge of shorts

Leg hem

MINA THE CAT CUSHION (p. 10)
Bow

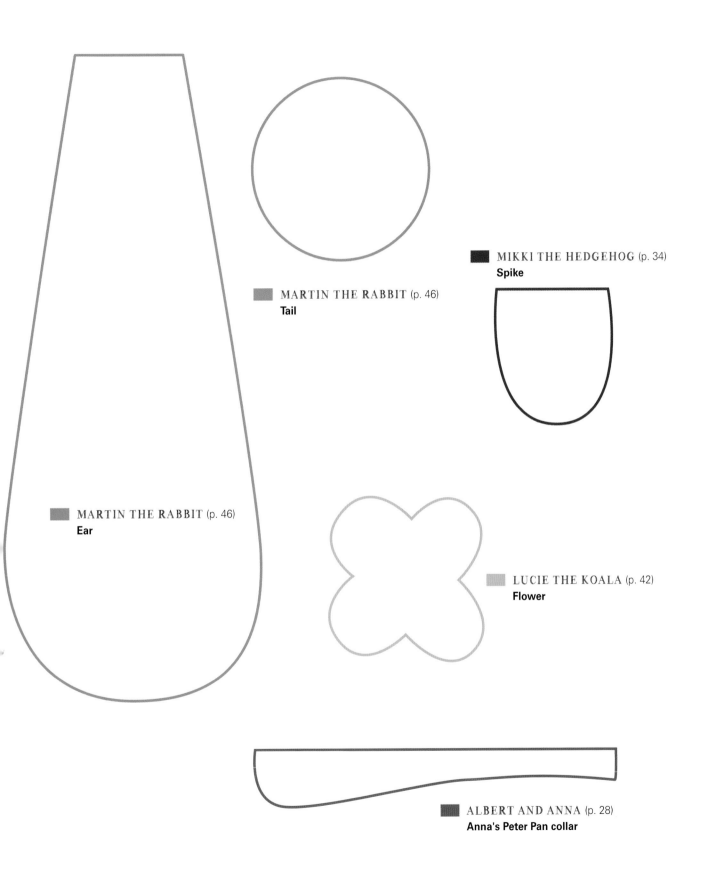

MARTIN THE RABBIT (p. 46)
Tail

MIKKI THE HEDGEHOG (p. 34)
Spike

MARTIN THE RABBIT (p. 46)
Ear

LUCIE THE KOALA (p. 42)
Flower

ALBERT AND ANNA (p. 28)
Anna's Peter Pan collar

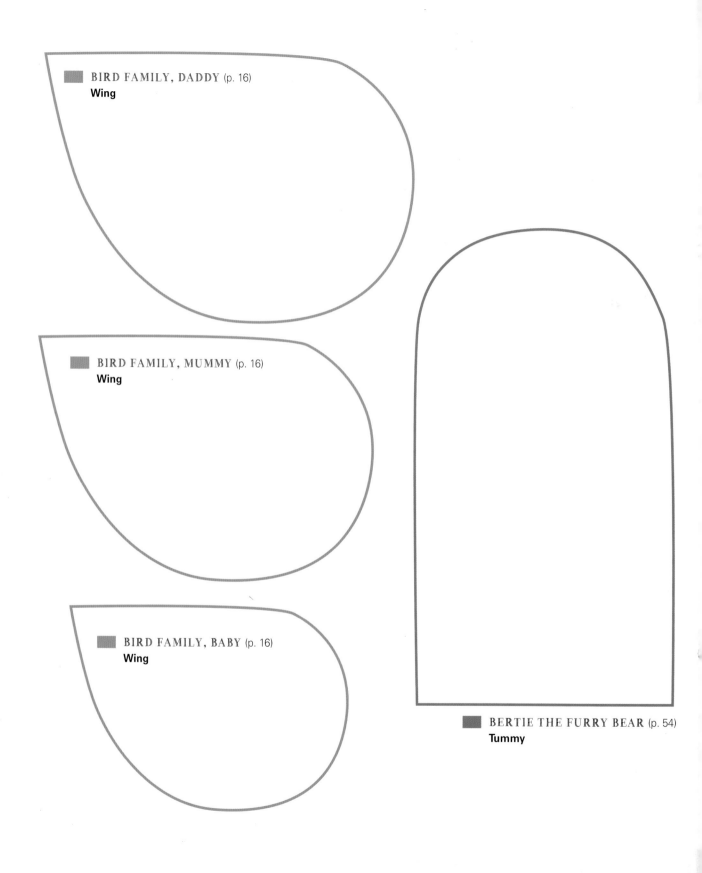

BIRD FAMILY, DADDY (p. 16)
Wing

BIRD FAMILY, MUMMY (p. 16)
Wing

BIRD FAMILY, BABY (p. 16)
Wing

BERTIE THE FURRY BEAR (p. 54)
Tummy